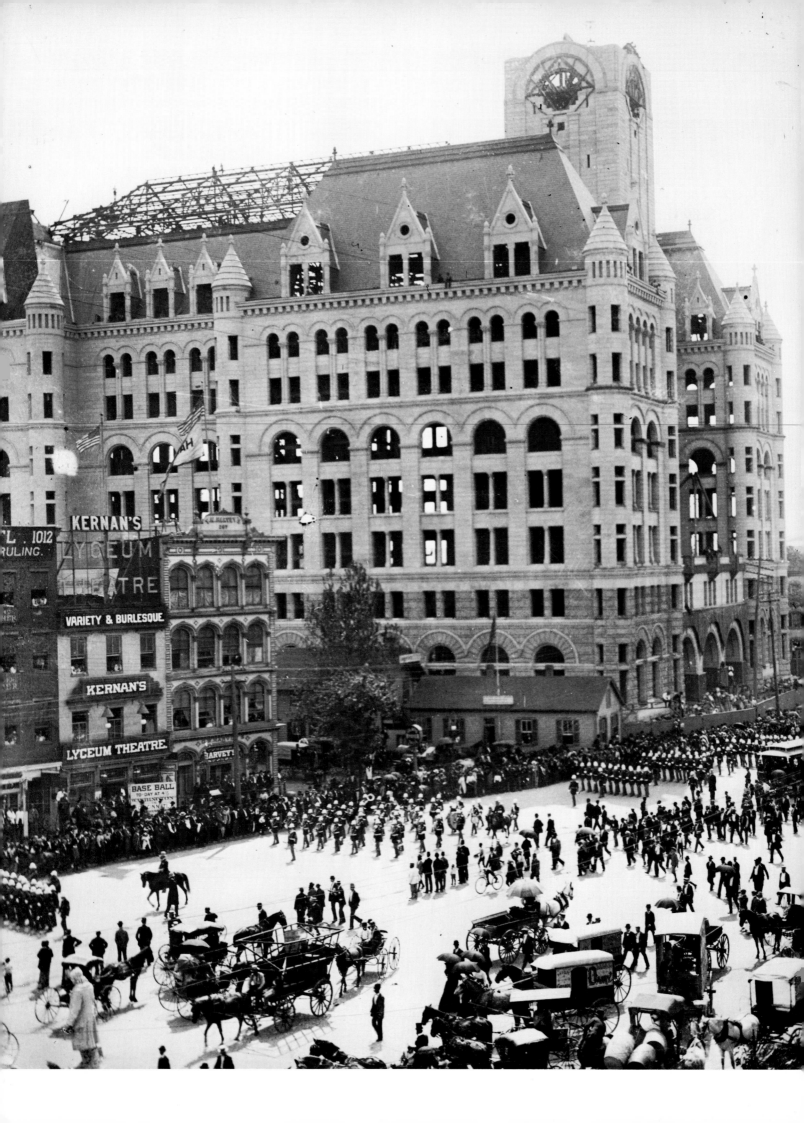

Old Washington, D.C.
IN EARLY PHOTOGRAPHS
1846-1932

by

ROBERT REED

Dover Publications, Inc.
New York

Frontispiece. **Pennsylvania Avenue and 11th Street, NW, 1894.** Taken during a Labor Day parade, the photo shows the unfinished Post Office and Kernan's Lyceum Theatre.

Published in Canada by General Publishing Company, Ltd., 30 Lesmill Road, Don Mills, Toronto, Ontario.
Published in the United Kingdom by Constable and Company, Ltd.

Old Washington, D.C., in Early Photographs, 1846–1932, is a new work, first published by Dover Publications, Inc., in 1980.

Book design by Carol Belanger Grafton

International Standard Book Number: 0-486-23869-5
Library of Congress Catalog Number: 79-52841

Manufactured in the United States of America
Dover Publications, Inc.
31 East 2nd Street
Mineola, N.Y. 11501

INTRODUCTION

Because of the vast changes that have taken place in the cityscape of Washington, D.C., its residents and visitors have difficulty in visualizing the old city as it once appeared. For there was a time when cows grazed within sight of the Capitol (see photograph 44), when the site now occupied by the majestic National Archives was a bustling market (photograph 65) and when today's commercial F Street east of 14th Street, NW, was a quiet residential neighborhood (photograph 130).

In selecting the illustrations for *Old Washington in Early Photographs*, I have intended to show Washington as it existed—a city of neighborhoods and people as well as the politically active capital city of marble landmarks, imposing government buildings and familiar picture-postcard views. The time span covered by the photographs is essentially the last half of the nineteenth century, with several incursions into the twentieth century for various editorial considerations. I have decided not to include pictures of the old Virginia section of the District of Columbia. The trans-Potomac part of the District was returned to Virginia in 1846, so long ago that the two areas, Washington City and the northern Virginia jurisdictions of Arlington and Alexandria, have developed quite different identities over the years.

These photographs show that Washington was not a great city, either visually or architecturally, in its early years. Views of Pennsylvania Avenue between the Capitol and the White House, the center of the city's commercial life, even as late as 1865, testify to the provincial appearance of the capital city. Though the city was laid out by Pierre Charles L'Enfant to rival the capitals of Europe, Washington was, in fact, for many years decidedly ungrand—an undeveloped southern town of muddy, sparsely settled streets and swampy lowlands. Sprinkled here and there were six or seven imposing Greek Revival government buildings which only seem to point up the general shabbiness of the rest of the city.

One must remember that Washington dates only from 1800. New York City, on the other hand, was settled in 1625, Boston in 1630, Philadelphia in 1683, and Baltimore in 1729. Washington developed slowly, retaining a provincial appearance well into the third quarter of the nineteenth century, when other East Coast cities were considerably more populous and sophisticated, architecturally as well as socially.

It was not really until after the Civil War that Washington began to take on the appearance of a major American city. In the 1870s Washington was well on its way to assuming a position of wealth and importance. The great expansion of the power of the federal government after the war gave Washington national significance. Also, about this time, under the leadership of City Governor Alexander Shepherd, work began on an extensive plan to make physical improvements, particularly in grading and paving streets, constructing sewers and planting trees. The fortunes of the city seemed assured, and great numbers of people began moving into the capital.

The photographs in the book are organized basically in an east-to-west arrangement: from Capitol Hill along Pennsylvania Avenue to the old residential and commercial area around 7th Street, on to Lafayette Square and the White House, and then to Georgetown. This east-west sequence roughly follows the pattern of the historical development of the city.

Many people gave me valuable assistance in the preparation of this book, and I wish to express my sincerest thanks. Robert Truax, Curator of Prints and Photographs at the Columbia Historical Society, was generous enough to give many hours of his time to help with the selection of photographs and preparation of the captions; LeRoy Bellemy, Jerry Kern, Sam Daniel and George Hobart at the Prints and Photographs Division of the Library of Congress were helpful in my research and provided many useful suggestions; Miss Betty Culpepper and Mr. Alexander Geyger of the Washingtoniana Division of the Martin Luther King Memorial Library allowed me use of their picture files and collection of early city directories.

I am especially grateful to my photographer, Marty Hublitz, who copied old photographs from private collections for use in this book.

Marty's copies are often sharper and clearer than the originals.

For their help and interest I also want to thank Donald Meyers of the National Collection of Fine Arts; Tom Oglesby and Bea Menchaca of the National Archives; James Goode, Curator of the Smithsonian Castle; John H. White, Jr., Curator of the Division of Transportation at the Smithsonian; Ernest Connally and Marilyn Wandrus of the National Park Service; Mary Ison of the Historic American Buildings Survey; Mrs. Denis Gletten of the Moorland-Spingarn Center at Howard University; Mrs. Agnes Hoover of the Navy Yard Museum; Mrs. Florian Thayn of the Office of the Architect of the Capitol; Perry Fisher of the Columbia Historical Society; Mrs. Billie Hamlet of the National Zoological Park; Fred Weiderhold of the D.C. Department of Environmental Services, and Bernard Nordlinger and Lawrence Gichner, collectors of Washingtoniana.

PHOTOGRAPH CREDITS

[References are to photograph numbers]

Library of Congress: *frontispiece*, 2, 5, 7–9, 11, 16, 20, 35, 38, 40, 61, 62, 64, 66, 68, 77, 83–90, 92, 93, 96, 100, 101, 103, 106, 108, 111, 112–116, 118, 120–122, 124, 127, 128, 131–135, 137, 138, 140, 142–144, 147, 148, 150, 152, 153, 158, 162–166, 169, 170–172, 176, 179, 184, 185, 188, 189, 191, 192, 194, 198, 201, 213, 221.

Smithsonian Institution: 1, 17, 41, 42, 52, 79, 94, 109, 157, 193, 218, 222.

Fine Arts Commission: 3, 6, 12, 139, 175.

Moorland-Spingarn Research Center, Howard University: 160.

National Zoological Park: 223.

Office of the Architect of the Capitol: 4, 37, 58, 65, 70, 72, 74, 75, 81, 107.

Public Buildings Service, National Archives: 10.

National Archives: 39, 44, 45, 76, 82, 159, 174, 211.

Washingtoniana Division, D.C. Public Library: 13, 54, 55, 57, 63, 67, 73, 80, 91, 117, 146, 154, 155, 167, 173, 182, 197, 206, 209, 214, 219.

Columbia Historical Society: 14, 15, 18, 22–29, 31, 36, 46, 48, 49, 50, 51, 59, 60, 69, 71, 78, 95, 97–99, 102, 104, 110, 119, 125, 126, 129, 136, 141, 145, 149, 151, 156, 161, 177, 178, 180, 181, 186, 187, 190, 195, 196, 199, 200, 202–205, 207, 208, 210, 215–217, 220.

Robert A. Truax Collection: 19, 130, 212.

Museum of African Arts: 21.

U.S. Marine Corps: 30, 123.

Department of the Navy: 32–34, 183.

Department of Agriculture: 43, 47, 56, 168.

LIST OF PHOTGRAPHS

IX.
THE WHITE HOUSE AND LAFAYETTE SQUARE

GENERAL VIEWS

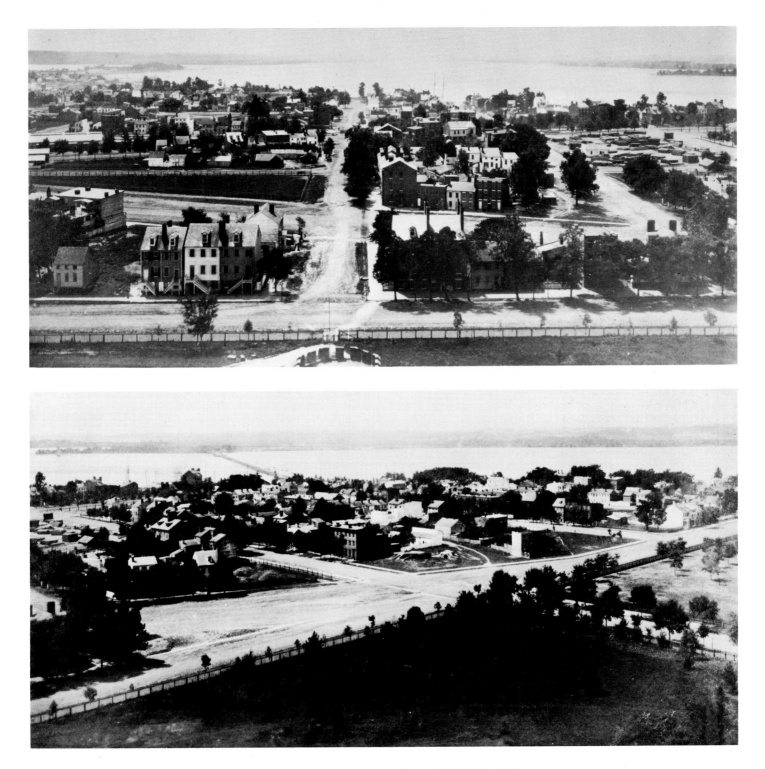

Top: **1. Panorama of Southwest Washington, August 18, 1863.** The view, taken by Titian Ramsay Peale from the central tower of the Smithsonian Building, shows Independence Avenue in the foreground, Virginia Avenue running diagonally, and 10th Street at the center, extending to the Potomac River waterfront. At the time, this area was closely built up with dwellings and commercial establishments. Today much of it is occupied by the Forrestal Building and L'Enfant Plaza.

Bottom: **2. Panorama of Southwest Washington, August 18, 1863.** A continuation of the Peale view shows at the center the intersection of Independence Avenue, Virginia Avenue and 12th Street. To the left of center is the Long Bridge over the Potomac to Virginia. The masts of ships are visible to the left of the bridge.

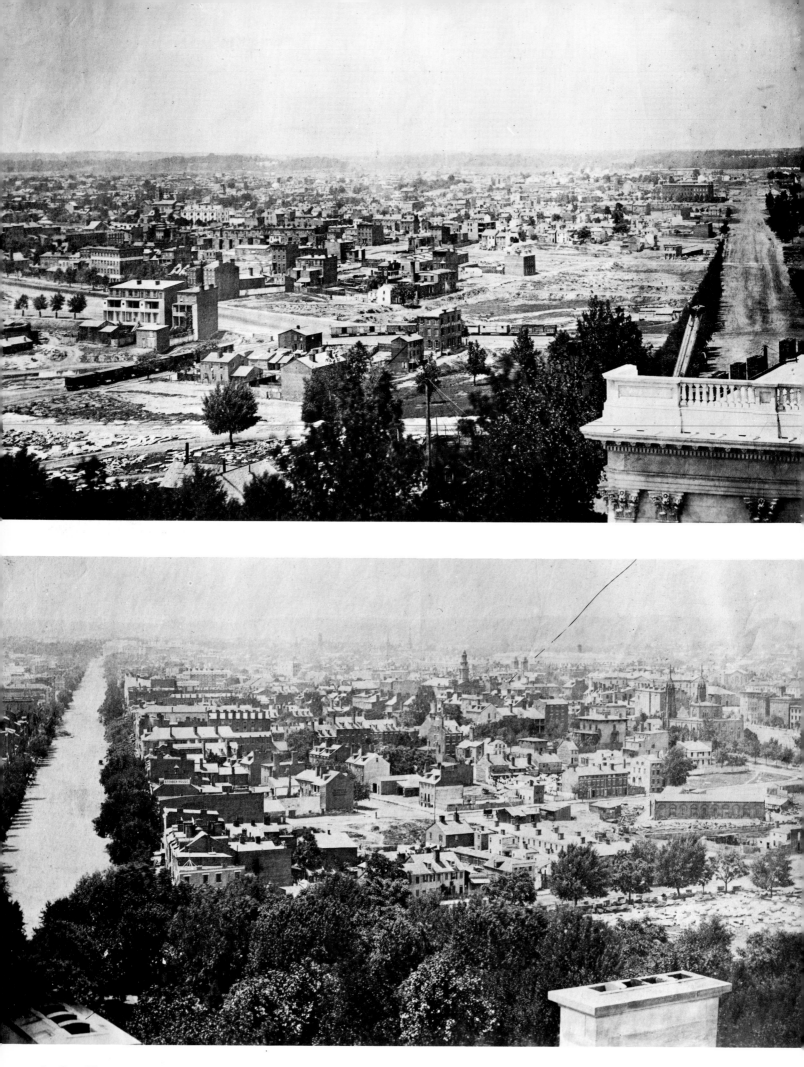

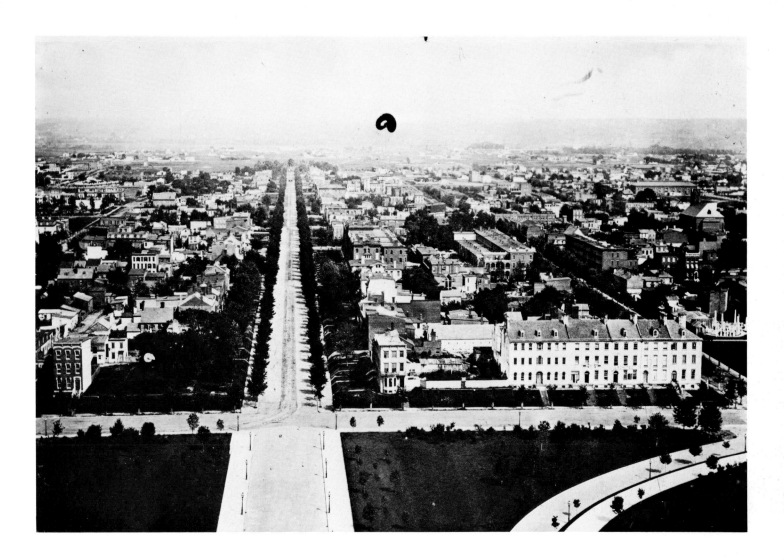

Opposite, top: **3. Northwest from the Capitol, June 27, 1861.** New Jersey Avenue is at the right. A building marked "Depot House" in the center foreground stands in front of two trains of cars on the old Baltimore & Ohio Railroad tracks.

Opposite, bottom: **4. Northwest from the Senate Wing of the Capitol, 1861.** A view taken two months after the start of the Civil War shows Pennsylvania Avenue (left) and Indiana Avenue (far right). The area between the Capitol and the White House was the oldest and most densely settled portion of the city, closely built up with houses, inns, hotels, churches and public buildings.

Above: **5. Capitol Hill, East from the Dome, ca. 1880.** 1st Street runs across the lower foreground; East Capitol Street extends to the Anacostia River in the distance. The Eastern Market is the long brick building at the upper right. Carroll Row (now the site of the Library of Congress) occupies the right corner. Otherwise Capitol Hill looks rather the same today—a neighborhood of low brick town houses and elm trees.

Over: **6. Pennsylvania Avenue from the Capitol, 1893.** The tower of the pyramidal roof at the left (along the tear in the photograph) marks the Baltimore & Potomac Railway Terminal, now the site of the National Gallery. At the upper right are the Patent Office and, below and slightly to the right, Old City Hall.

Pages 6 and 7: **7. View from the Washington Monument, 1900.** The area in the bottom half of the photo, between Pennsylvania and Constitution Avenues, was an industrial complex of warehouses, storage yards, factories and disorderly houses. It is now covered by Federal Triangle. The intersection of 14th Street and Pennsylvania Avenue is at the left center. Far left, at Ohio Avenue and 15th Street, is the Panorama Building, which displayed scenes of the battles of Manassas and Bull Run. In the right foreground is the old Pepco powerhouse on Constitution Avenue. The Post Office Building, just completed, stands at the far right.

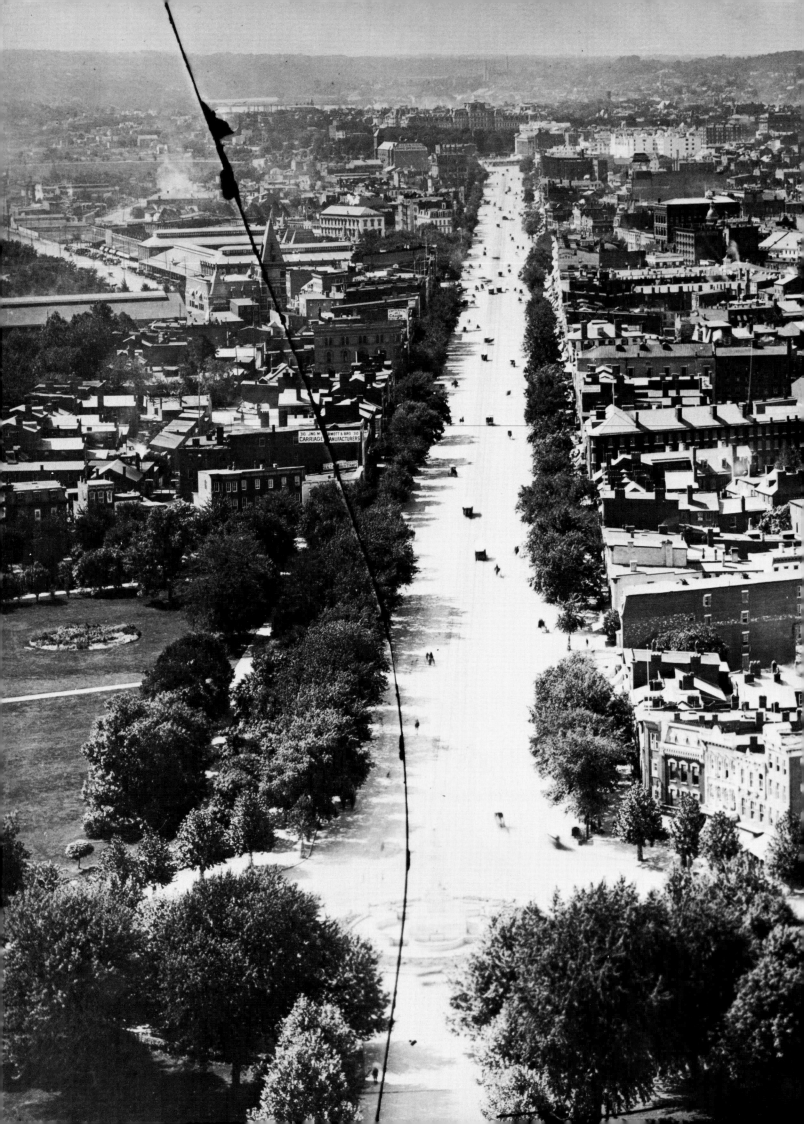

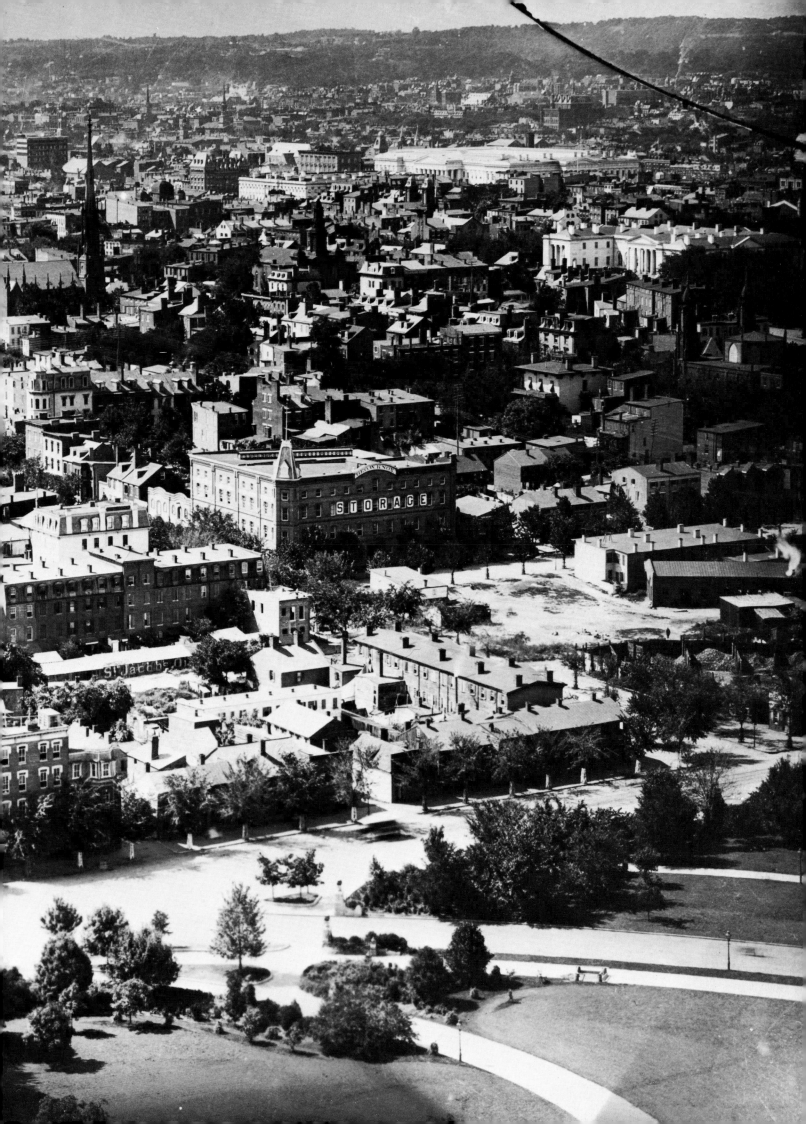

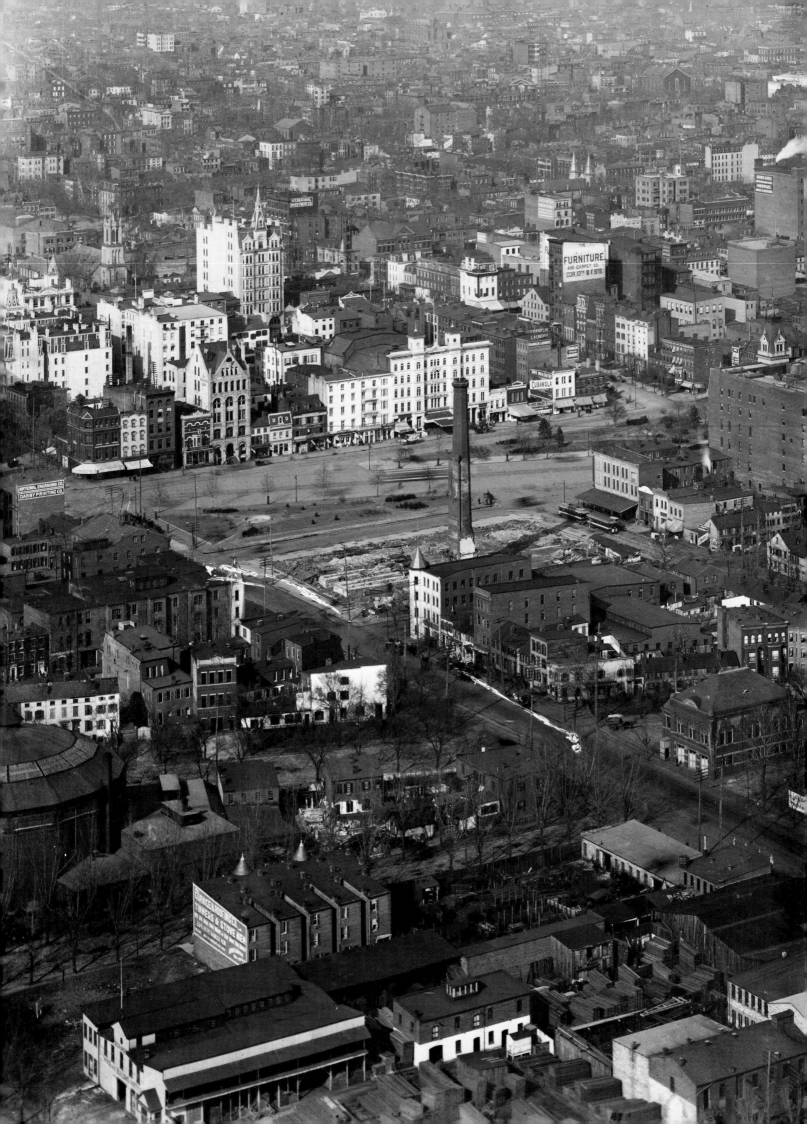

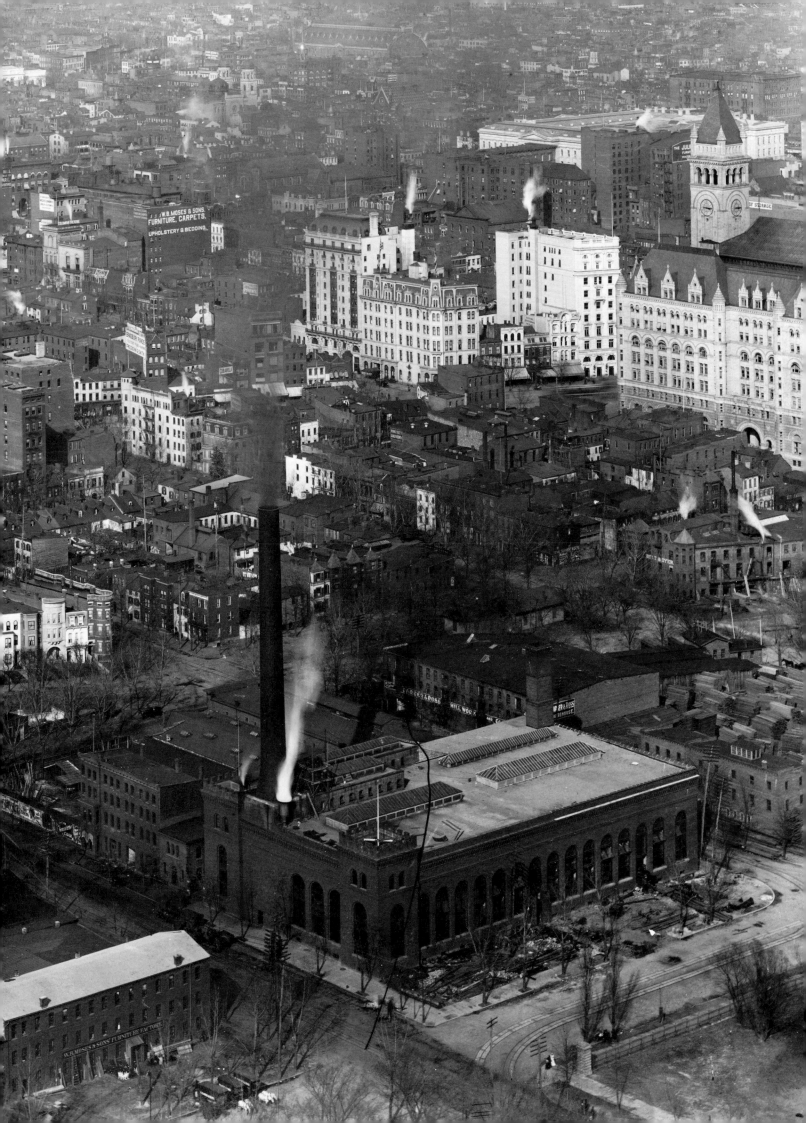

THE CAPITOL

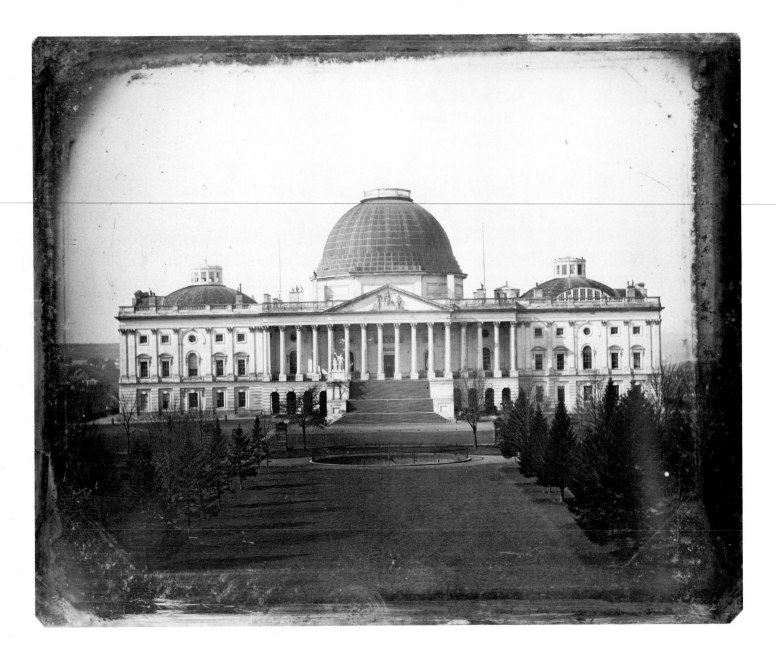

8. East Front of the Capitol, ca. 1846. This daguerreotype, attributed to John Plumbe, Jr., is the earliest-known photo of the building. It was purchased in 1977 by the Library of Congress. After the devastation of Washington by the British in 1814, Benjamin H. Latrobe and later Charles Bulfinch rebuilt the Capitol, which had originally been designed by William Thornton. Here the wooden dome designed by Bulfinch can be seen. The statue on the north side of the portico has not yet been put into place.

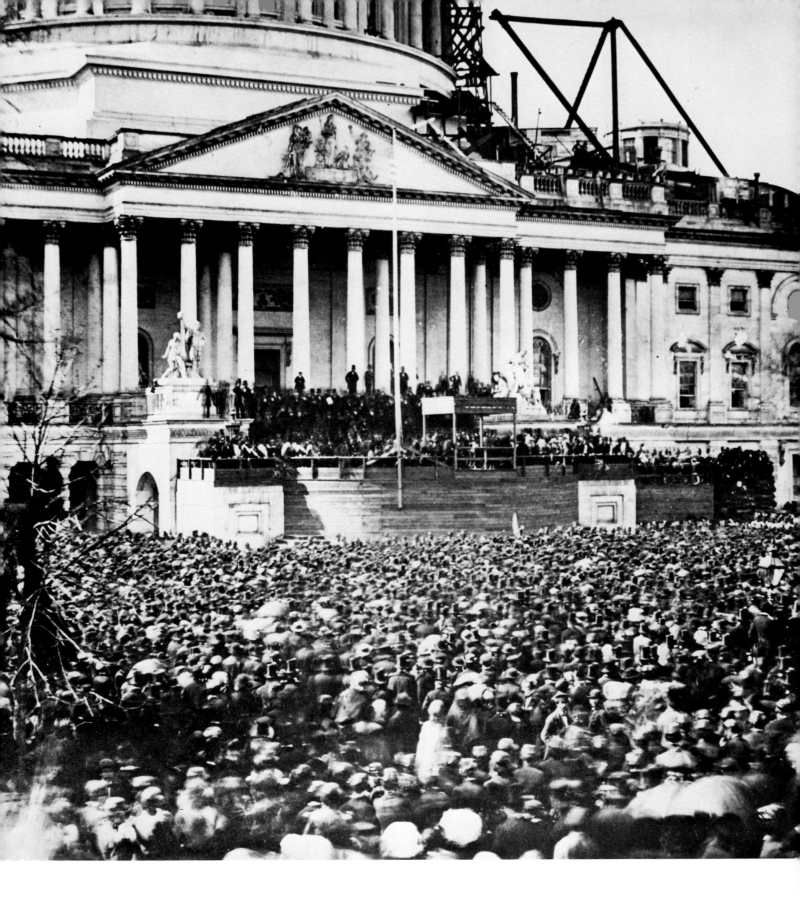

9. Lincoln's First Inauguration, March 4, 1861. By the 1840s it had become apparent that the Capitol would have to be enlarged to accommodate the needs of the growing Congress. Work, entrusted to Thomas U. Walter, began in 1851. At the time of Lincoln's first inaugural, the new dome and wings were still under construction. A high wooden barricade was put up to shield the platform on the portico from the crowds because of rumors that Lincoln might be shot.

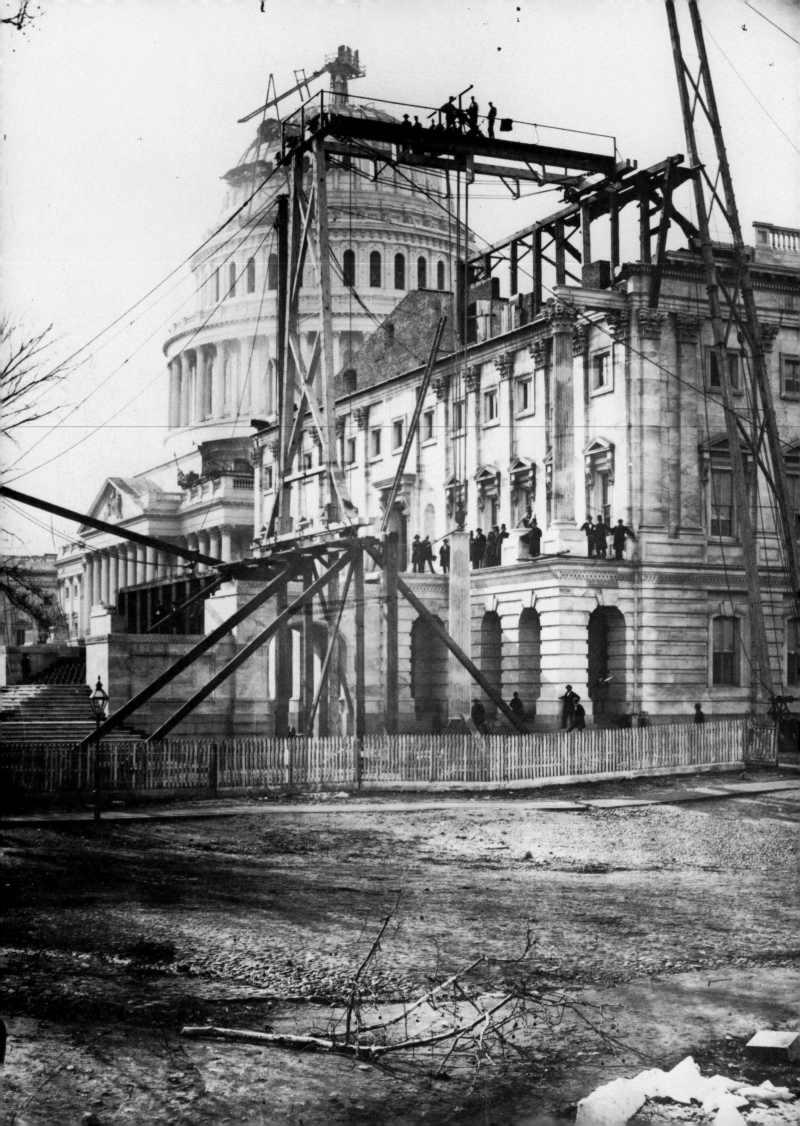

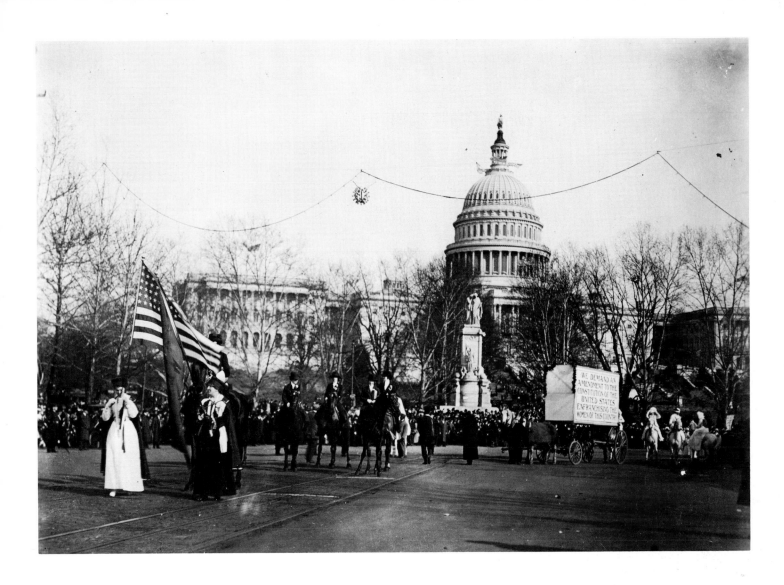

Opposite: **10. The Capitol, ca. 1862.** Walter's work on the Capitol was not finished until 1865. In this view, workers and onlookers watch the drum of a column being lifted into place. Behind them rises the dome, modeled on that of St. Peter's in Rome. There are 36 columns in the drum of the dome, one for each state at the time of construction. Thirteen columns in the lantern honor the colonies which be- came the original states. Scaffolding has been erected on top to facilitate the placement of Thomas Crawford's statue of Freedom. All of the trim, cornices and columns in the project were of cast iron painted to resemble marble. Above: **11. Women's Suffrage Parade, 1913.** Heading north- west up Pennsylvania Avenue, NW, the parade moves through Union Square below the west front of the Capitol.

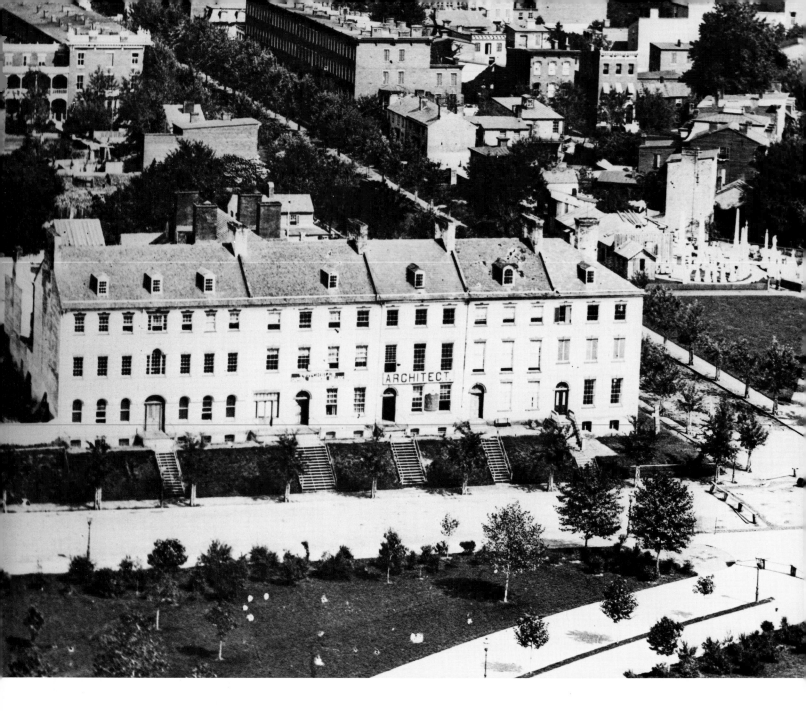

Above: **12. Carroll Row, 1st Street at Pennsylvania Avenue, SE, ca. 1880.** These five Federal town houses, built about 1805, faced the Capitol. The large house at the left was originally used as a tavern. The third house from the right was at one time the boardinghouse of Mrs. Spriggs, where Lincoln lived as a congressman from Illinois in 1847–48. All the houses were torn down in 1886 to make way for the Library of Congress.

Opposite, top: **13. The Library of Congress, 1889.** Students and their teacher admire the Neptune Fountain in front of the newly opened library, 1st Street and Independence Avenue, SE. The sculpture is the work of Hinton Perry.
Opposite, bottom: **14. The Elias Boudinot Caldwell House, 204–208 Pennsylvania Avenue, SE, ca. 1918.** The Supreme Court allegedly met here after the Capitol was burned by the British in 1814. Caldwell was clerk of the court.

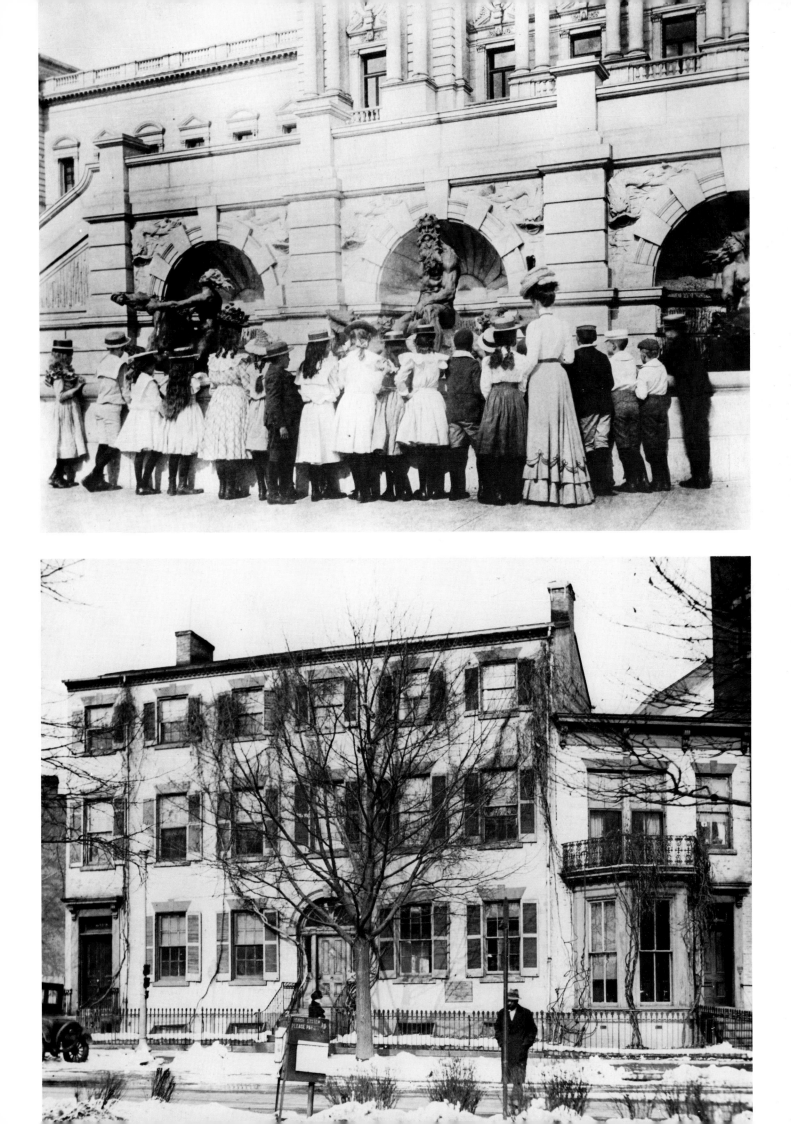

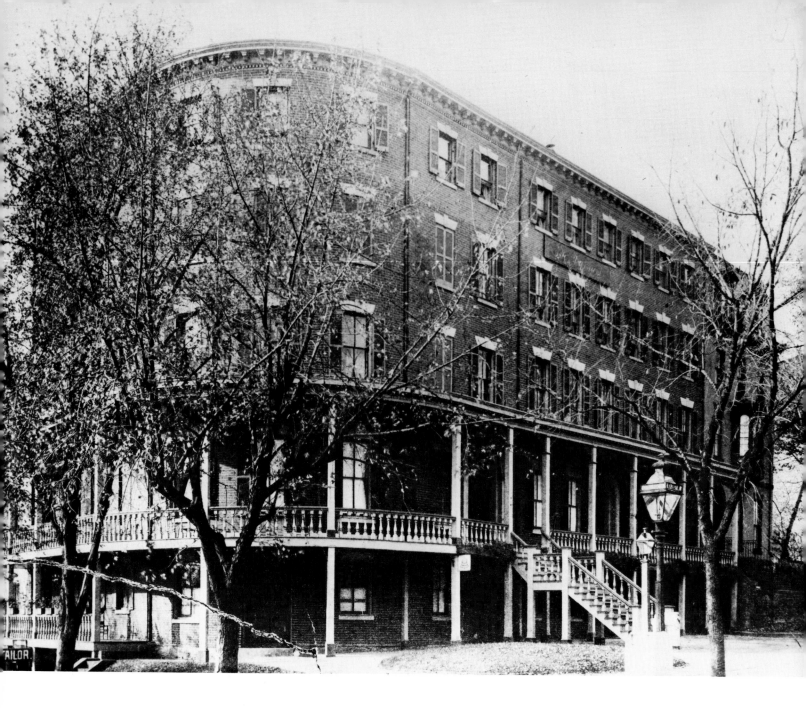

Above: **15. The Varnum Hotel, New Jersey Avenue and C Street, SE, ca. 1895.** Land speculator Thomas Law built this row of early houses and lived here in 1796 with his wife Elizabeth Parke Custis, a granddaughter of Martha Washington. The building later became a boardinghouse—one of many that once surrounded the Capitol, catering principally to congressmen. It was there that Thomas Jefferson lived when he served as Vice-President. He left the building to make his way to his first inauguration in 1801. The row eventually became the Varnum Hotel, which it remained until it was demolished to make way for the House of Representatives Office Building.

Opposite, top: **16. Henry Brock's Congressional Hotel, New Jersey and Independence Avenues, SE, 1903.** The hotel stood on the site adjacent to the Capitol grounds that is now occupied by the Cannon House Office Building. To the right is a row of early Capitol Hill town houses.

Opposite, bottom: **17. Purdy's Court, 1908.** This crowded back-alley slum was located on 1st Street near the Capitol.

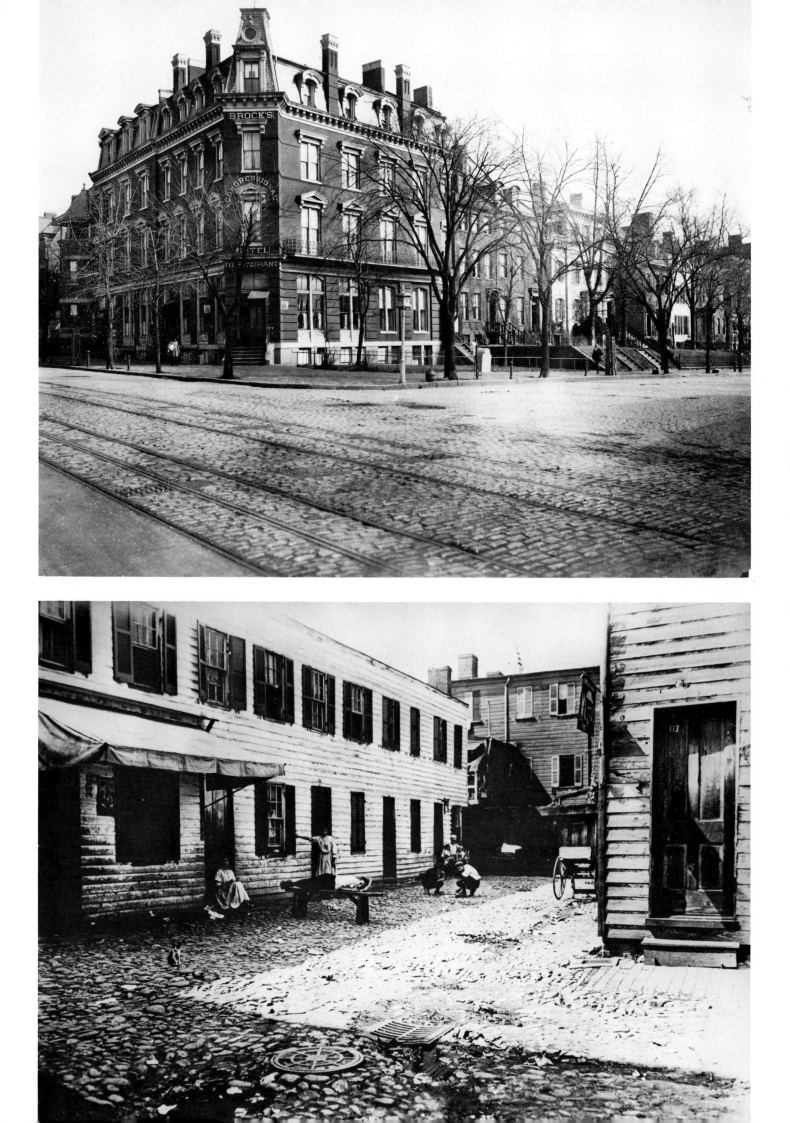

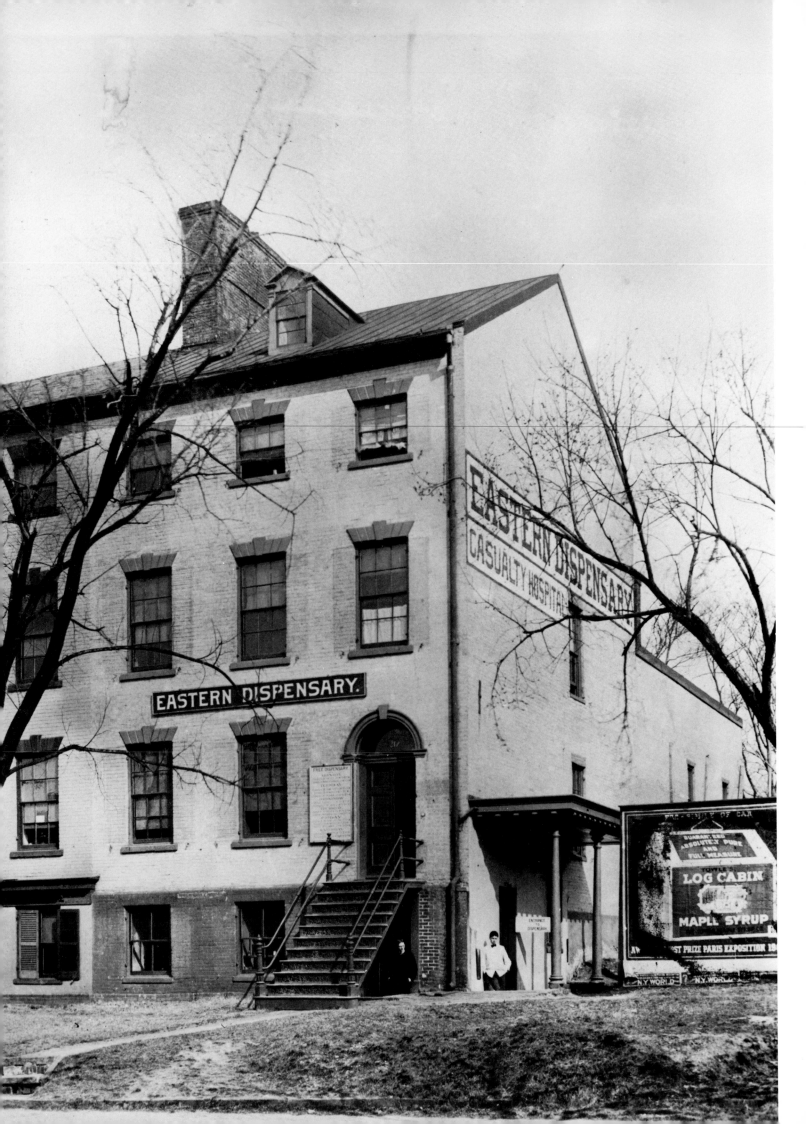

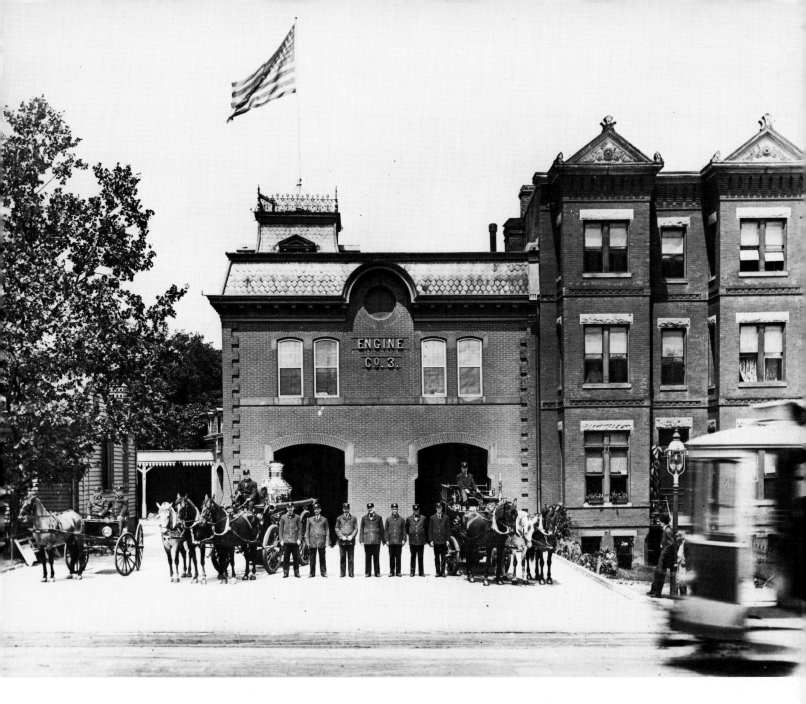

Opposite: **18. Eastern Dispensary, ca. 1900.** The Casualty Hospital's clinic, located in this Federal town house at 217 Delaware Avenue, NE, just north of the Capitol, treated only those who were unable to pay for medical attention.

Above: **19. Fire Engine Company No. 3, ca. 1890.** The fire-house stood at C street and Delaware Avenue, NE, just north of the Capitol, near the site of the present old Senate Office Building.

III.
CAPITOL HILL
AND THE NAVY YARD

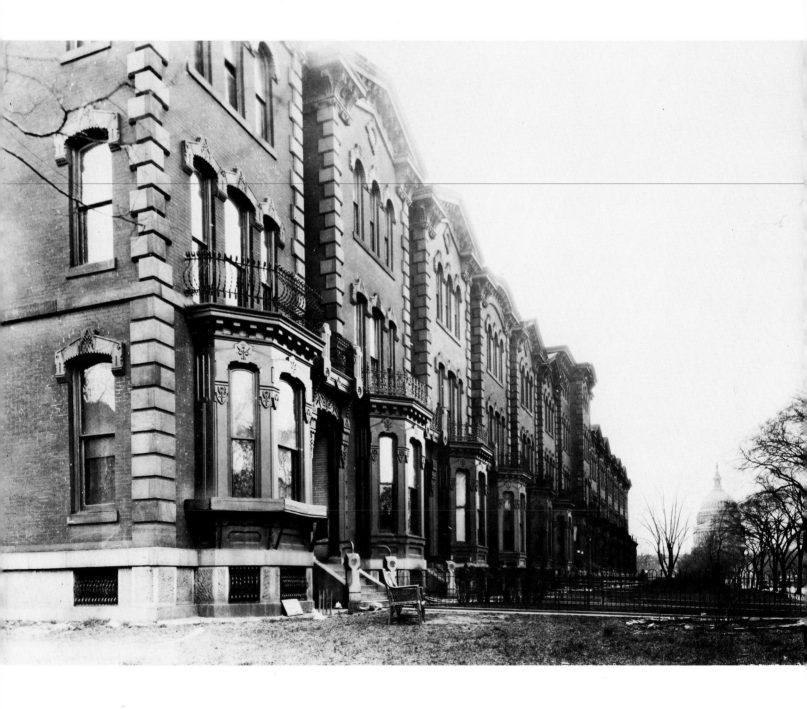

Above: **20. Grant Row, ca. 1880.** On East Capitol Street between 2nd and 3rd Streets, SE, Grant Row was torn down to make way for the Folger Shakespeare Library, dedicated in 1932.
Opposite, top: **21. Frederick Douglass and Family, 316 A Street, NE, 1885.** Douglass, an ex-slave, was an American statesman and editor of the weekly *New National Era.* The Douglass home now houses the Museum of African Arts.
Opposite, bottom: **22. Dr. Augustus C. Taylor's Drugstore, 2nd Street and Maryland Avenue, NE, 1906.** An alfresco ice-cream parlor has been set up in front of the store. The building, just behind the Supreme Court, still stands.

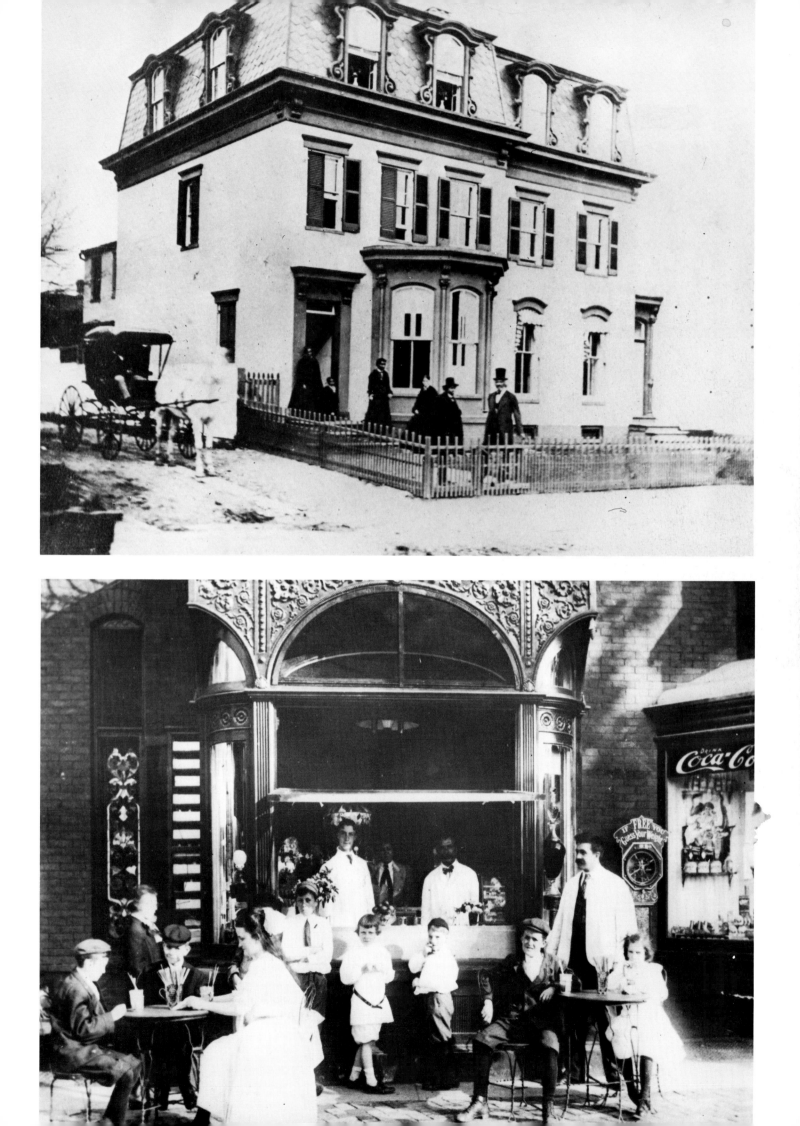

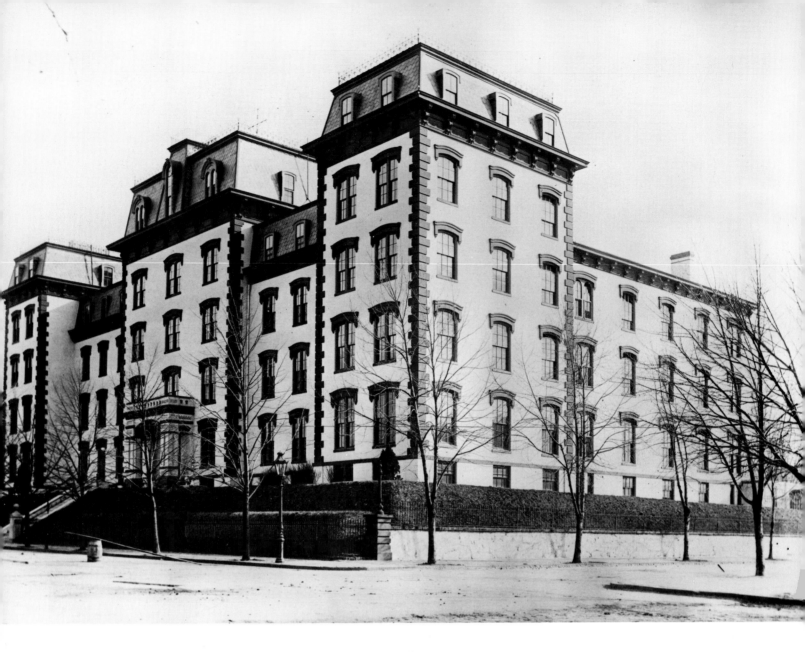

Above: **23. Providence Hospital, 2nd and D Streets, SE, ca. 1890.** Providence is the oldest hospital in Washington to remain in continuous service. Chartered by Congress in 1861 to assist the military during the Civil War, the hospital erected this building in 1872. In 1956 the hospital moved to new quarters at 1150 Varnum Street, NE, where it remains in operation. Until 1964, when it was demolished, the old structure housed the offices of the Commerce Department.

Opposite, top: **24. Corner Building, New Jersey Avenue and E Street, SE, ca. 1924.** The odd shape of the early nineteenth-century building was in part determined by Washington's street plan. L'Enfant's broad diagonal avenues,

intersecting at circles and squares, not only broke up what he called the "tiresome and insipid" gridiron pattern but also created a good many different pie-shaped building lots.

Opposite, bottom: **25. The Maples, 630 South Carolina Avenue, SE, ca. 1886.** Though only six blocks from the Capitol and now standing in the heart of bustling Capitol Hill, this old plantation house is shown as it looked when its setting was rural. The house was built in 1796 by William Duncanson, a tobacco planter. In 1809 it was purchased by Francis Scott Key. In 1936 it became Friendship House, a Quaker center for social work.

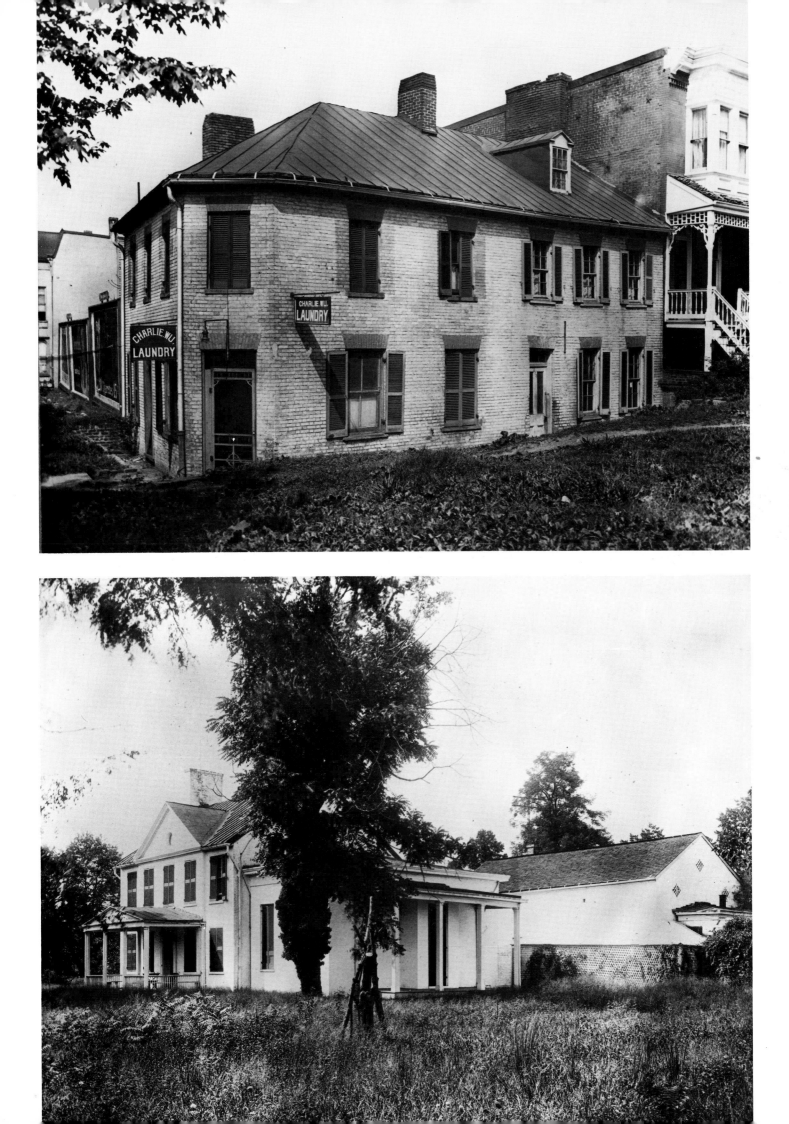

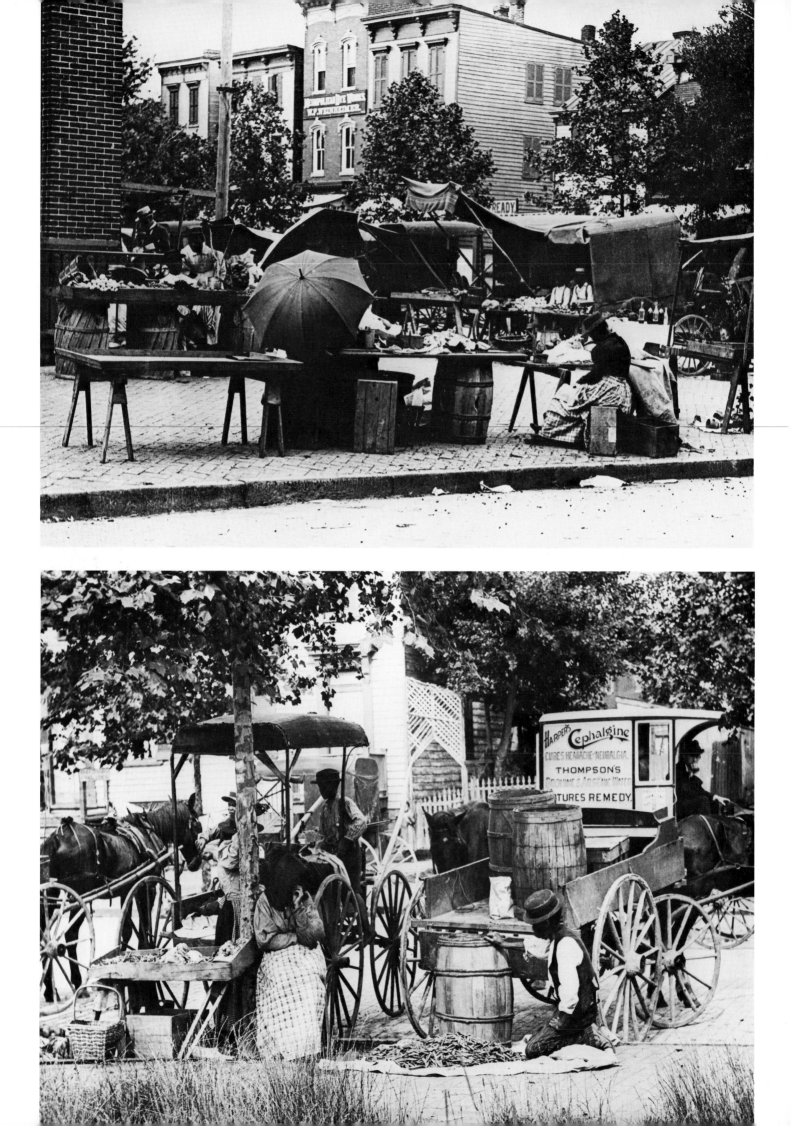

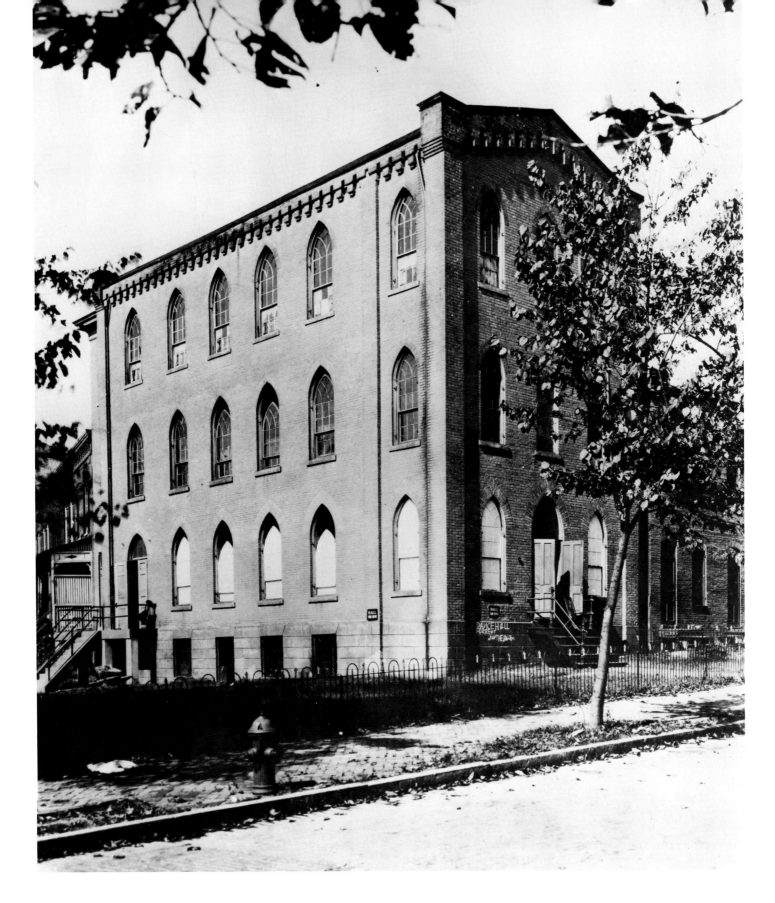

Opposite: **26 and 27. Eastern Market, 7th and C Streets, SE, 1889.** Dating from 1873, Eastern Market is one of the last of the old public markets still serving the city. The building was designed by Adolph Cluss, architect of the Smithsonian Arts and Industries Building and the Franklin School. A social center of new Capitol Hill, today a thriving business is done inside, where meats, seafood, poultry, pastry and vegetables are sold from stalls.

Above: **28. Naval Lodge Number 4, Masonic Hall, 5th Street and Virginia Avenue, SE, 1929.** Erected as a two-story building in 1821, the structure was raised to three stories in about 1867. (Note the difference in the tint of the bricks above the second floor.) After the Naval Lodge moved to a new, larger hall at 4th Street and Pennsylvania Avenue, SE, in 1895, this building became a meeting place for several Black Masonic organizations. It was demolished in the 1960s as part of the construction of the Southwest Expressway.

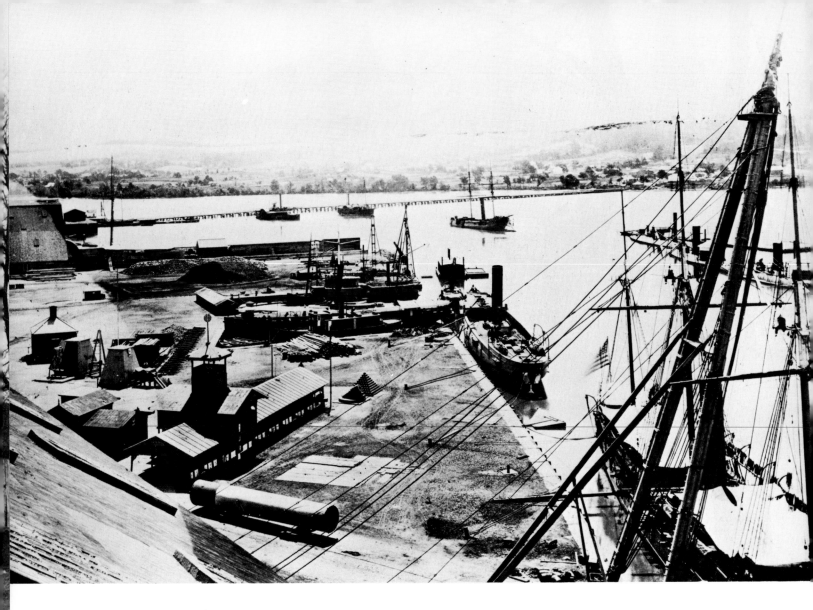

Above: **32. Navy Ordnance Yard, June, 1866.** In the center of this Brady view, which looks east across the Anacostia River and the 11th Street Bridge, is the captured Confederate ship *Stonewall*. Over the years presidential yachts have been moored at these docks.

Opposite, top: **33. Navy Ordnance Yard, June, 1866.** The Navy Yard had been actively involved with shipbuilding and ordnance-making since 1804. The dome of the Capitol can be seen faintly in the background of this photo by Brady and Co., while in the foreground ornamental cannon stand near neat stacks of round shot.

Opposite, bottom: **34. Officer's House, Navy Ordnance Yard,** **June, 1866.** This Brady photo shows one of the mid-Victorian officer's quarters that faced the drill field. Much of the yard was occupied by factories and warehouses.

Over: **35. The 2200 Block of Nichols Avenue, SE, 1917.** Across the Anacostia River from the Navy Yard is the Anacostia neighborhood. The Reardon family stores have been decked out to celebrate the Fourth of July. At the right is Thomas E. Reardon's store. At the left is William F. Reardon's ice-cream parlor, advertising "Velvet-Kind, the cream of all ice creams."

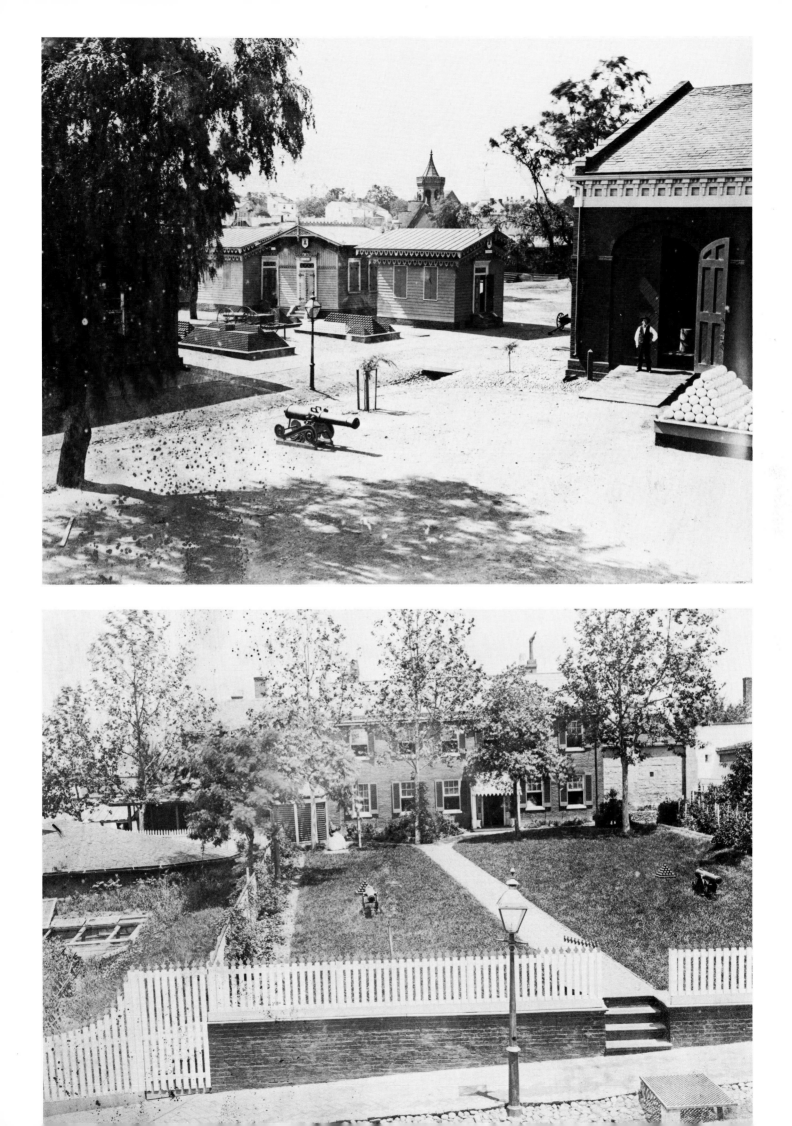

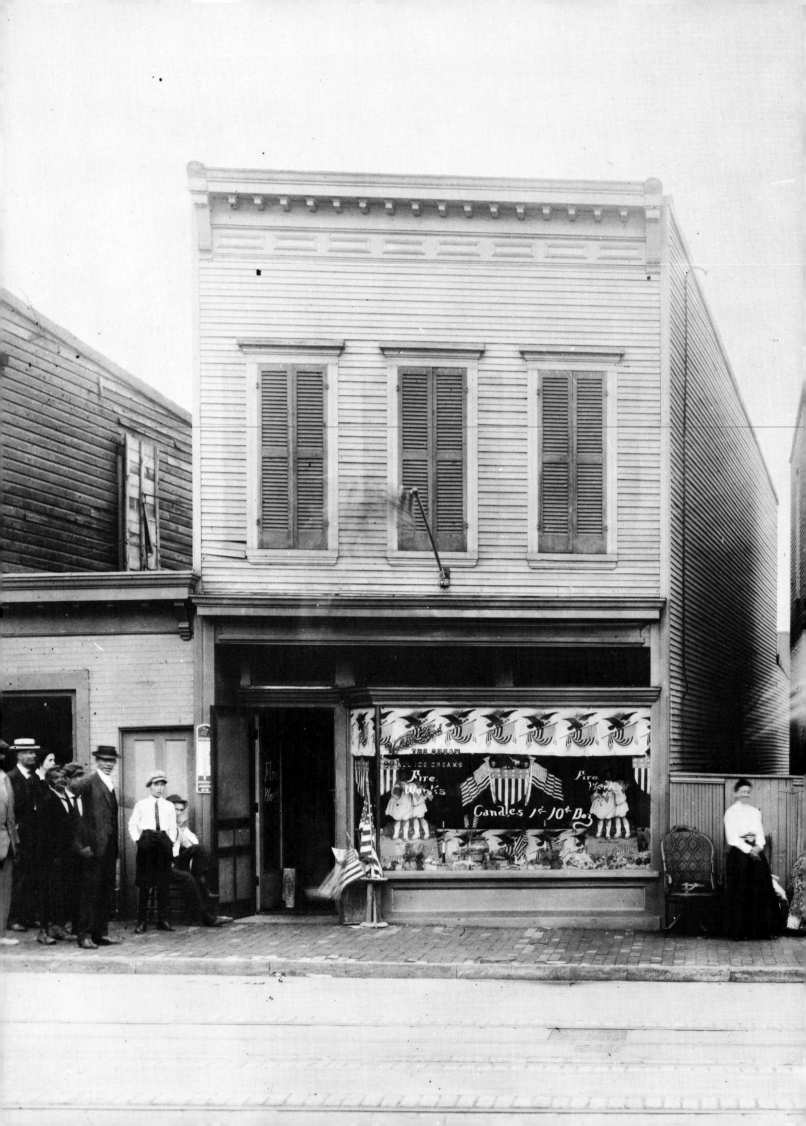

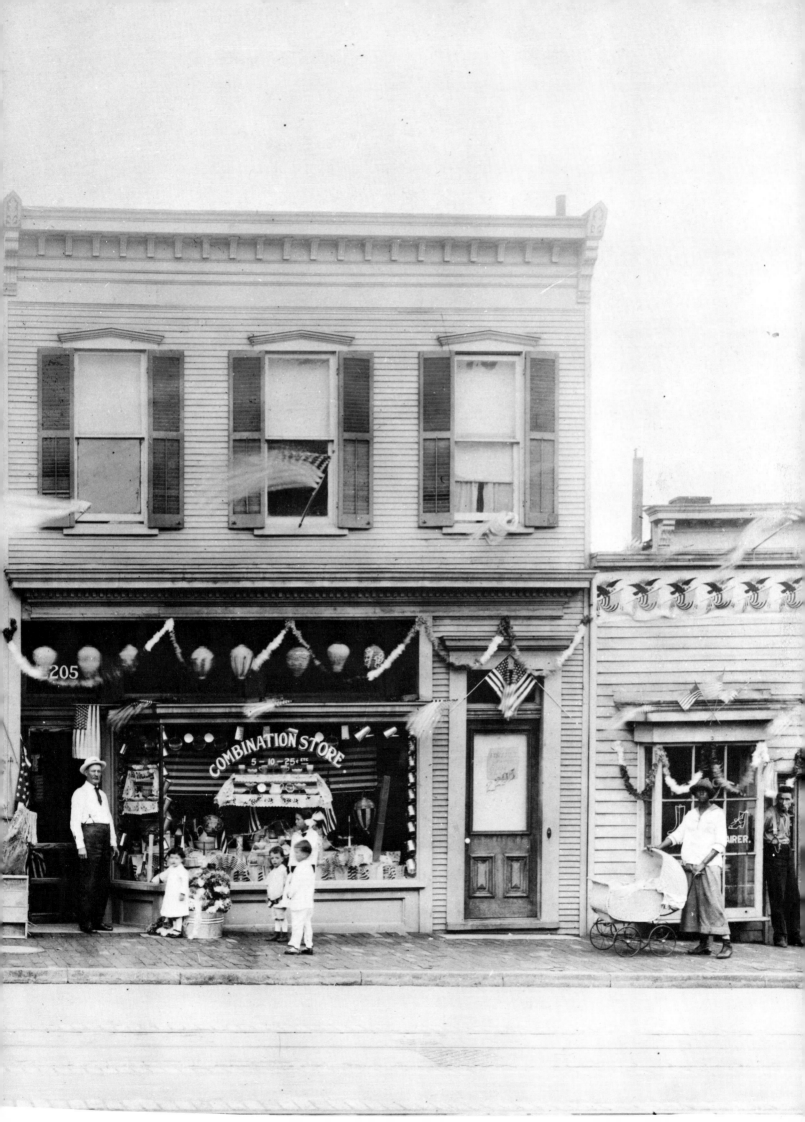

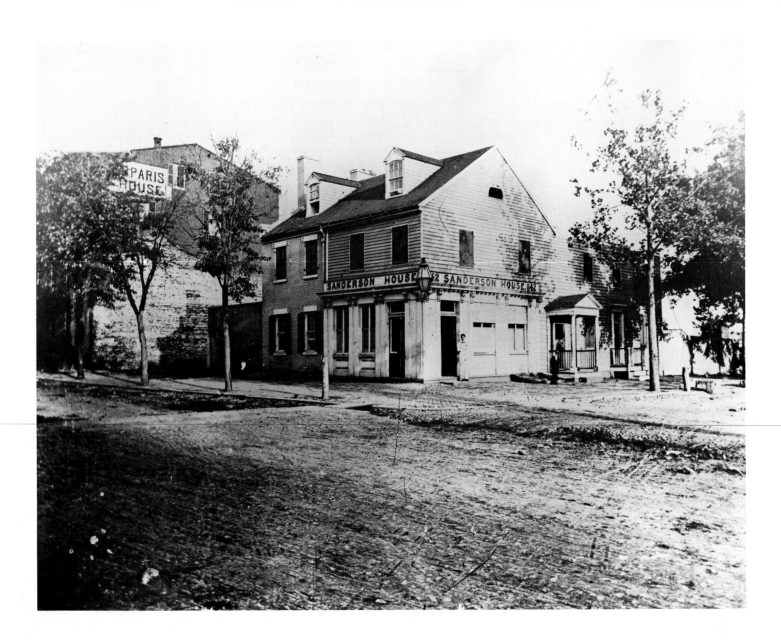

36. Sanderson House, 8th and L Streets, SE, ca. 1866. A restaurant, Sanderson House did a brisk trade because it stood near the main gate to the Navy Yard, in what was in the 1860s one of the more thickly settled parts of Washington. The photo was taken by Joseph E. Bishop.

IV.
OLD SOUTHWEST

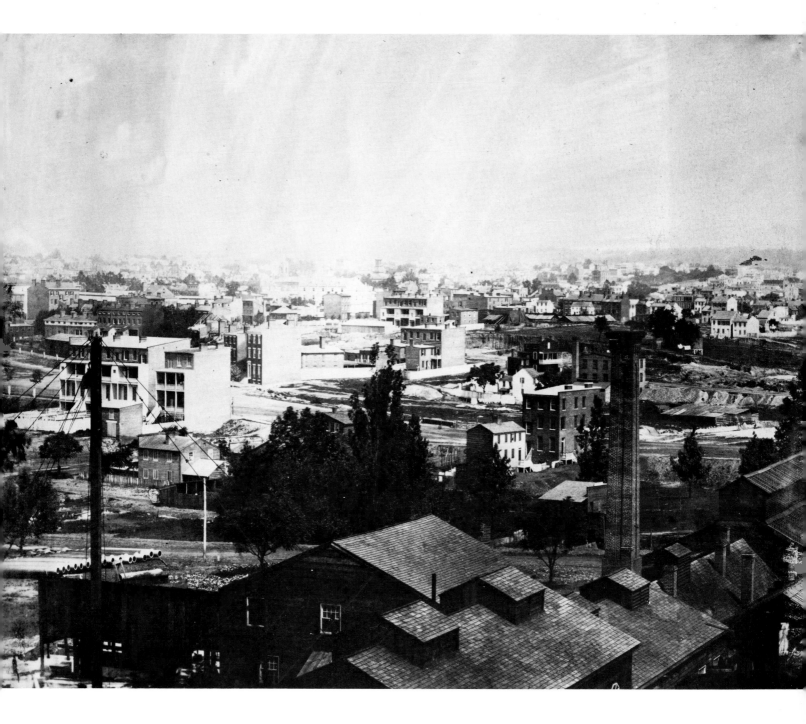

37. Southwest Washington from the Capitol, 1857. The chimney at the right belongs to the shed housing the stonecutting machinery used in the enlargement of the Capitol. Beyond is old Southwest Washington, a district heavily developed with residences, businesses and small manufacturers. All the structures are gone now, replaced by large federal office buildings, high-rise apartment houses and massive urban renewal projects.

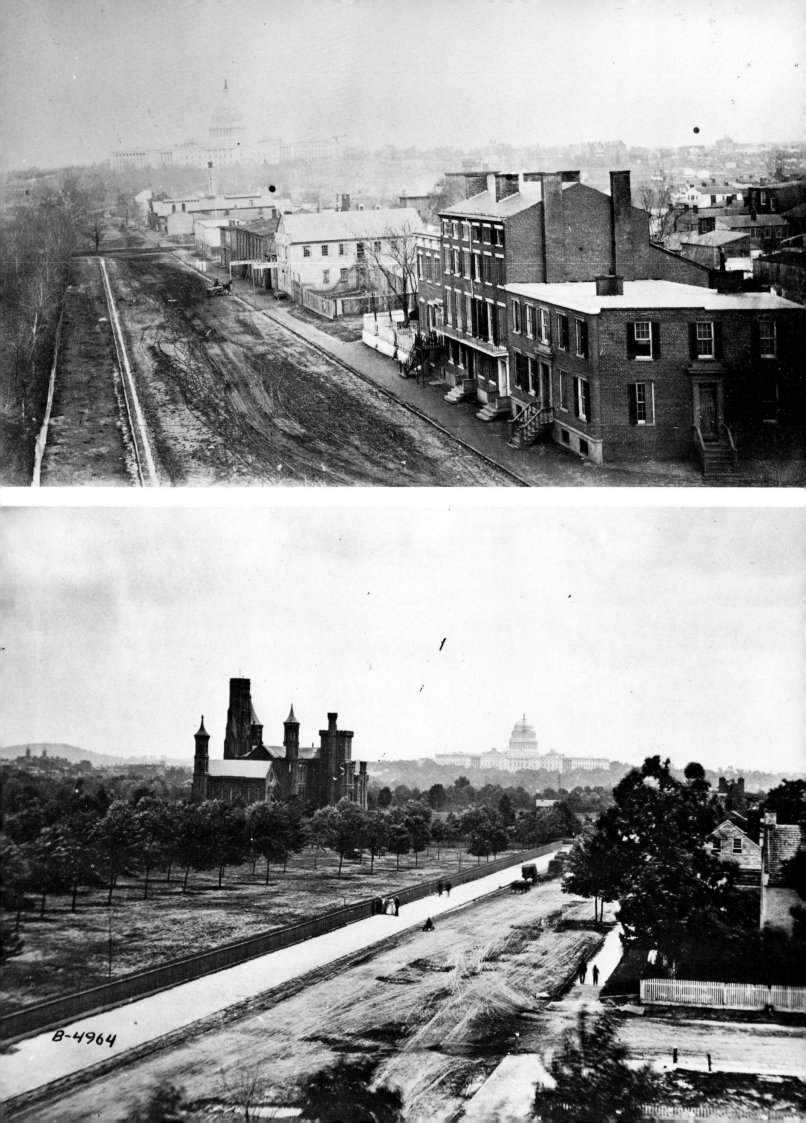

B-4964

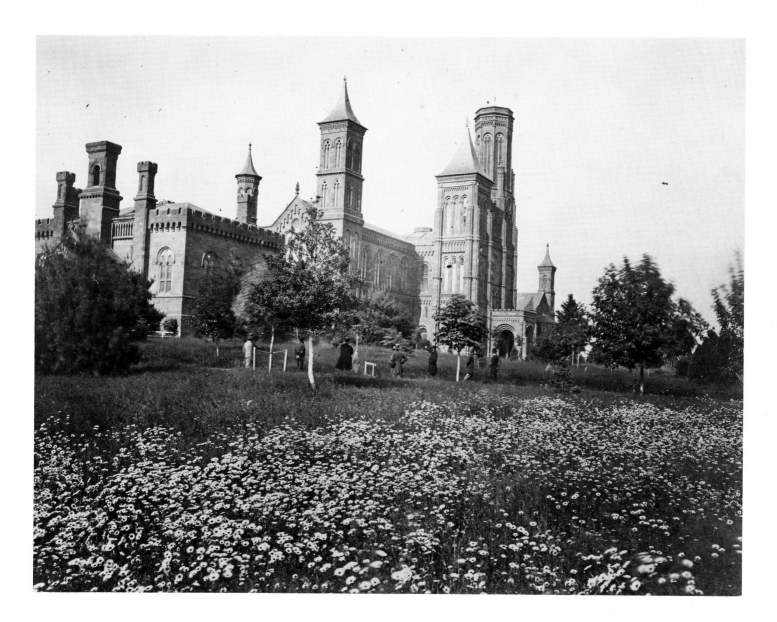

Opposite, top: **38. Maine Avenue Looking Northeast, April, 1865.** At this time Maine Avenue ran diagonally from 4th to 6th Streets, SW, through what is now the Mall. The white frame building beyond the brick residences has a sign over the sidewalk proclaiming it to be the business of Thomas Somerville & Robert Leitch, brass founders and ironworkers.

Opposite, bottom: **39. Independence Avenue and 12th Street, SE, 1863.** A photo by Mathew Brady shows the Smithsonian building and the Mall. The Smithsonian grounds were the first area of the Mall to be landscaped, beginning in 1849, while the building was under construction. The informal design incorporated 150 species of trees and shrubs.

Above: **40. The Smithsonian Institution, Jefferson Drive Between 9th and 12th Streets, SW, 1862.** One of the finest Gothic Revival buildings in America, the Smithsonian was designed by James Renwick and constructed of local Seneca sandstone between 1847 and 1855. James Smithson, a British scientist, had bequeathed $550,000 to the United States to found, in Washington, an institution to increase knowledge among men. This photo was taken by A. J. Russell.

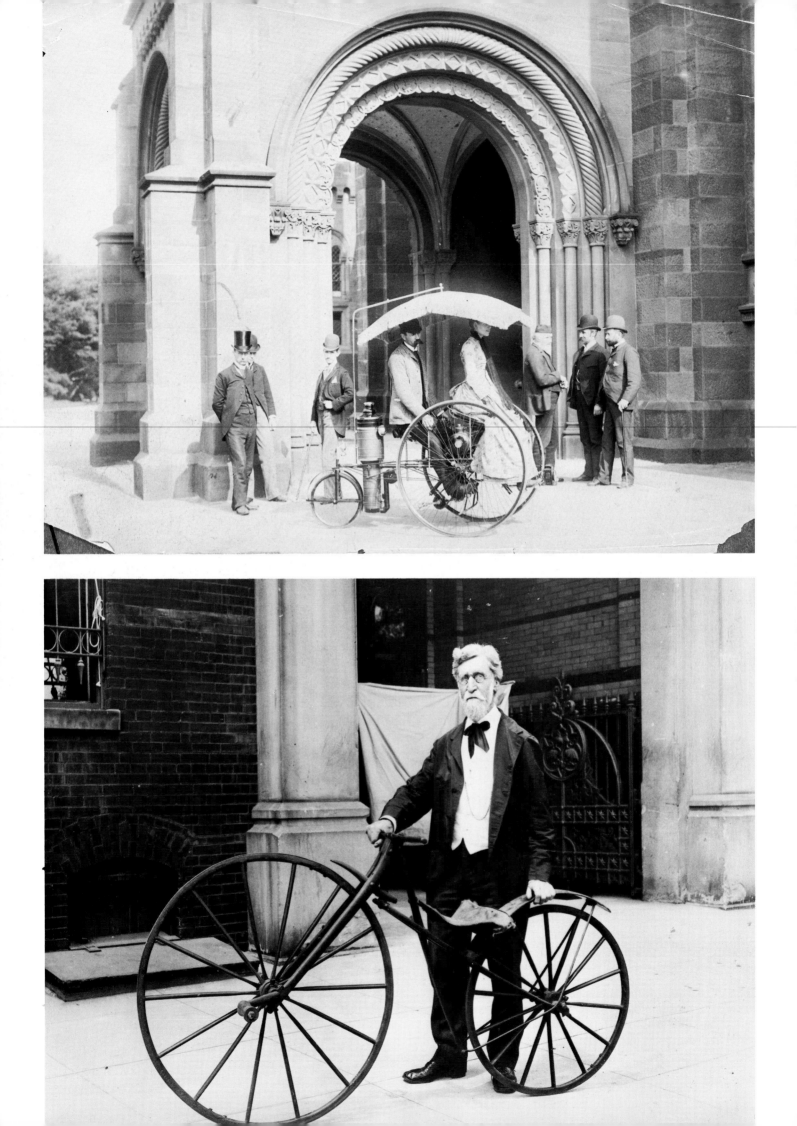

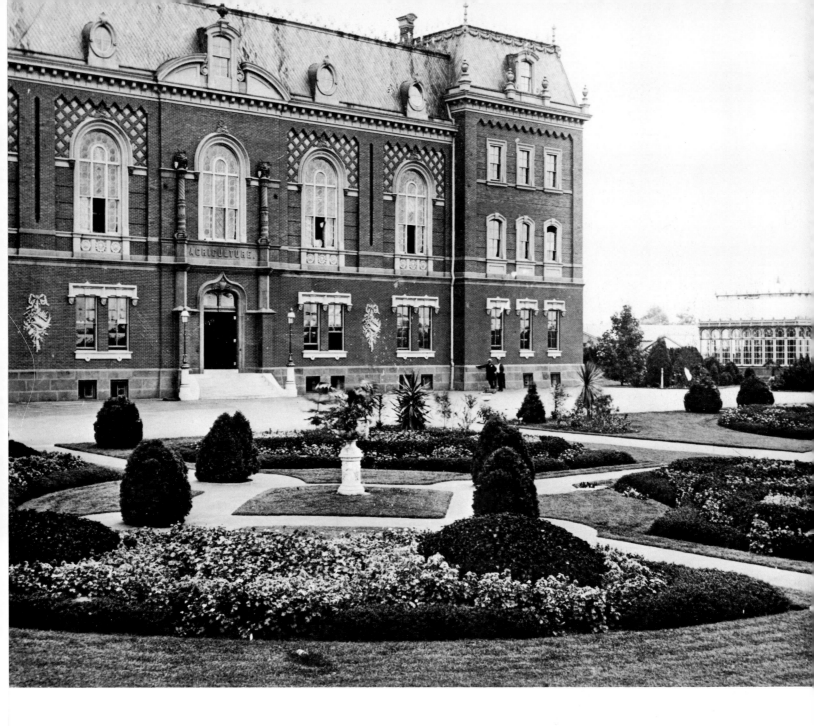

Opposite, top: **41. North Portico of the Smithsonian Institution, 1886.** A lady braves a ride in Lucius D. Copeland's steam tricycle.

Opposite, bottom: **42. United States National Museum, 9th Street and Jefferson Drive, SW, 1914.** Curator of Technology George C. Maynard poses with an old velocipede or "boneshaker" near the east door of the Smithsonian.

Above: **43. Department of Agriculture, the Mall, ca. 1875.** Designed by Adolph Cluss in what was called the Renaissance style with red brick walls, brownstone trim and mansard roof, the building was erected in 1868. This view of the north facade includes the formal gardens and conservatory.

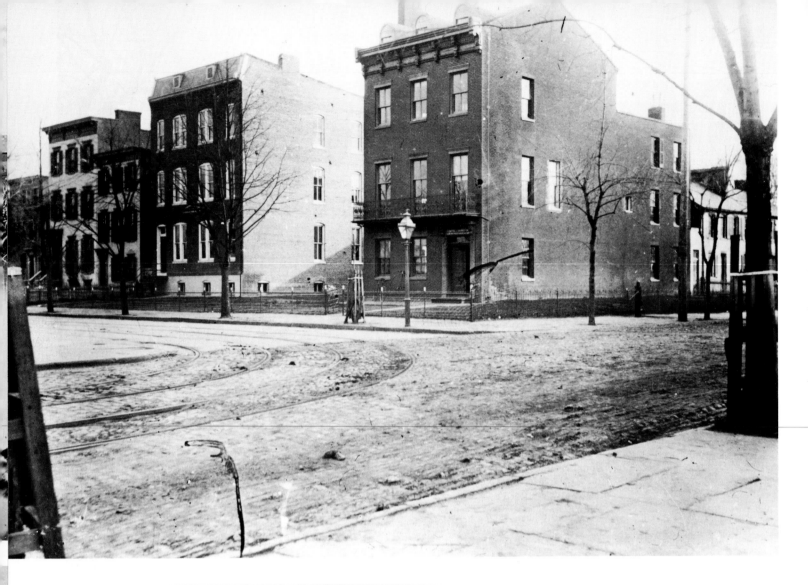

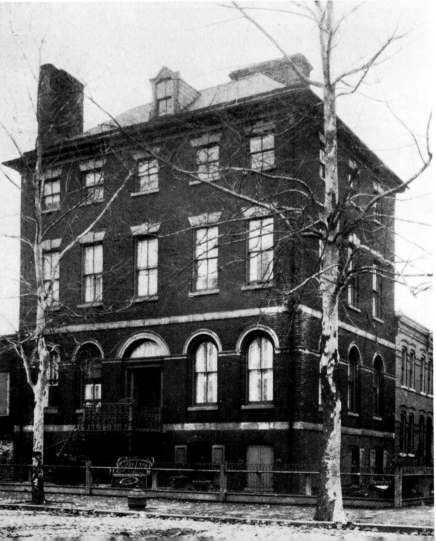

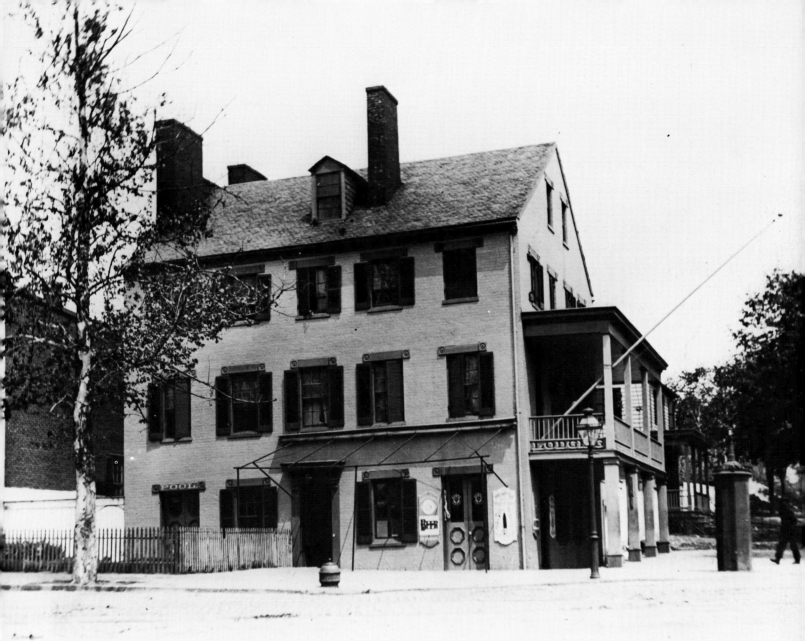

Opposite, top: **47. Town Houses, 14th Street and Independence Avenue, SW, ca. 1892.** The houses were built in the middle of the nineteenth century. The site is now occupied by the Department of Agriculture's South Building.

Opposite, bottom: **48. Thomas Law House, 6th and N Streets, SW, ca. 1900.** Built in 1795, the house was occupied briefly by Law and his wife Eliza, a noted hostess. It is sometimes called the Honeymoon House because the Laws spent their honeymoon there. It stands today amid high-rise apartment buildings.

Above: **49. Tavern-Hotel, 10th and Water Street (now Maine Avenue), SW, ca. 1900.** This Potomac waterfront area was once noted for its wharves used by excursion boats, fish markets and seafood restaurants.

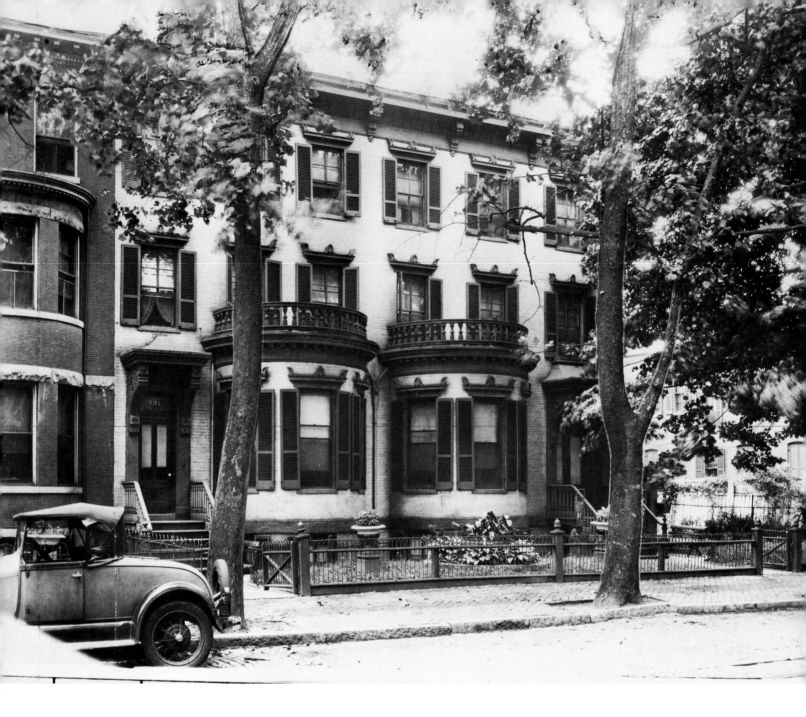

Above: **50. Nos. 394–96 11th Street Between C and D Streets, SW, ca. 1920.** The residences were built in 1860 by Charles B. Church, who lived in the building on the right.
Opposite, top: **51. L. T. Bridwell's Saloon and Oyster Bar, 615 7th Street, SW, 1890.** The sign at the left advertises locally brewed Christian Heurich Beer. The Columbia His-

torical Society is now housed in the Heurich mansion on New Hampshire Avenue near Dupont Circle.
Opposite, bottom: **52. Columbus Scriber, 119 E Street, SW, October 9, 1863.** Titian R. Peale's photo shows Scriber, a free Black, seated in front of his flour and feed business.

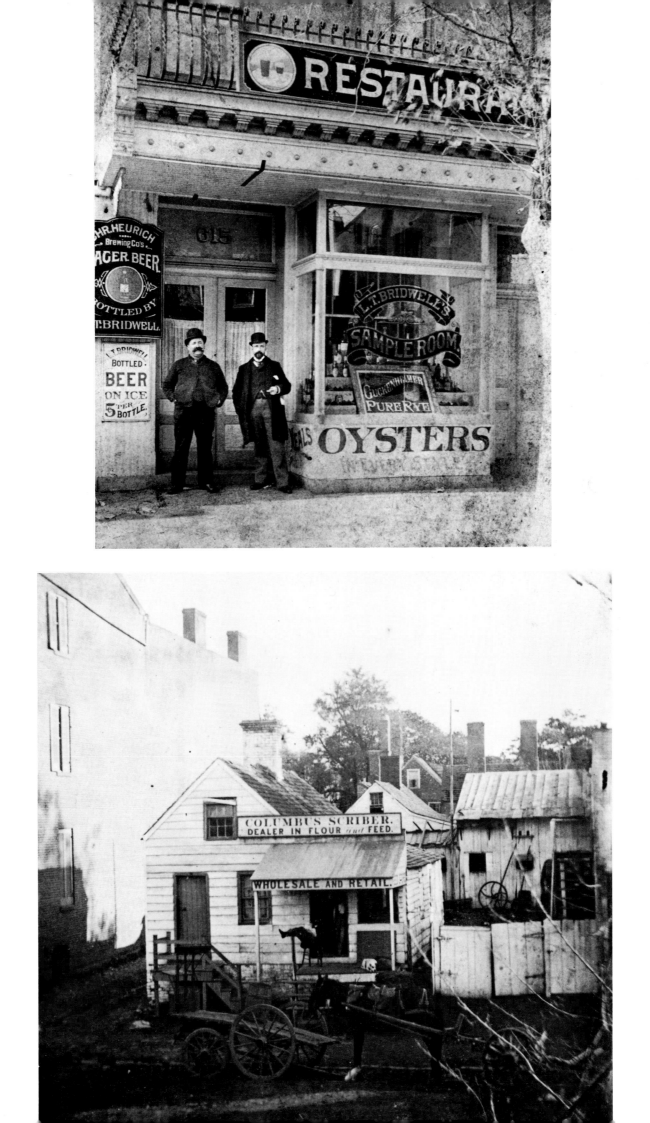

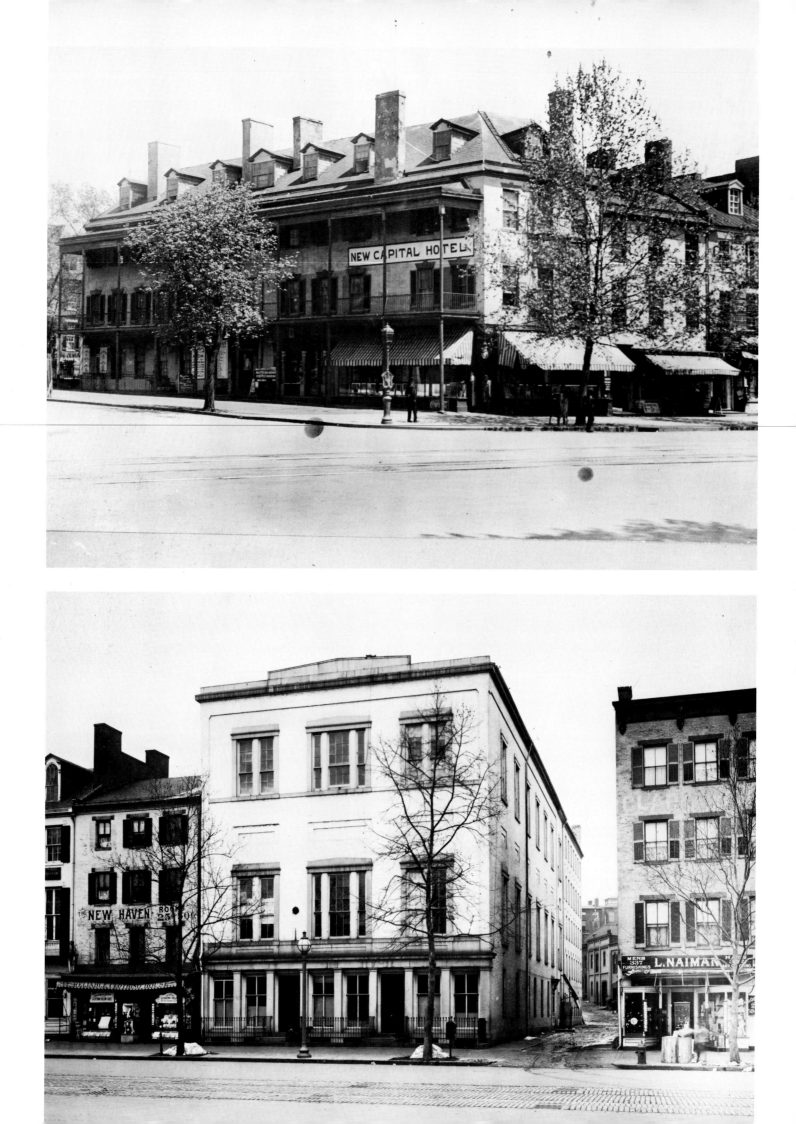

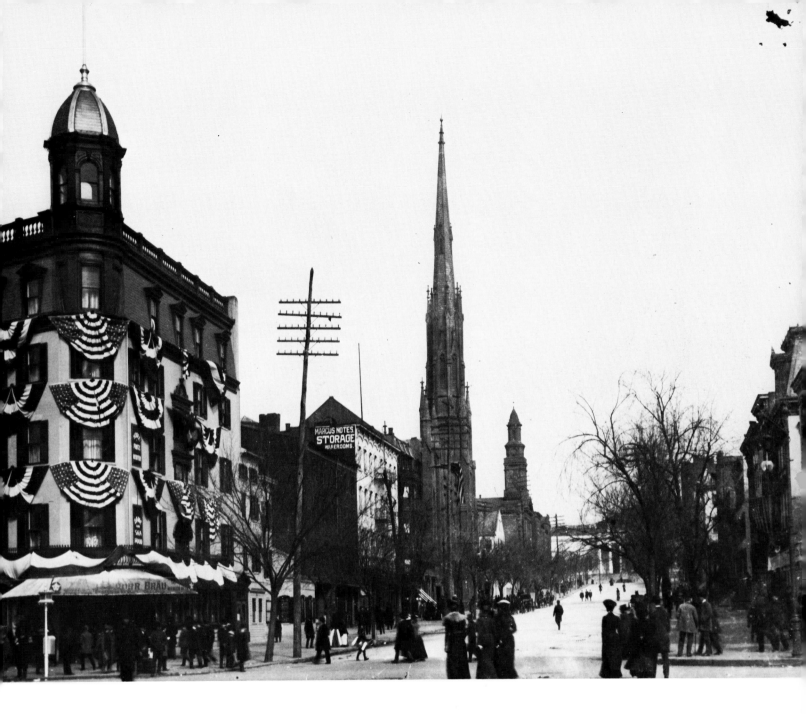

Opposite, top: **55. New Capital Hotel, 3rd Street and Pennsylvania Avenue, NW, ca. 1895.** Originally the St. Charles Hotel, the structure was built soon after the British invasion in 1814. Some columns from the burnt Capitol went into the 3rd Street entrance. In addition to housing a number of noted statesmen—Jackson, Calhoun, Clay, Webster and Van Buren—it was a favorite rendezvous for Indian chiefs in town on missions to the government. It was demolished about 1930.

Opposite, bottom: **56. Jackson Hall, 339 Pennsylvania Avenue, NW, ca. 1919.** The scene of many historic festivities, this Masonic building was erected in 1845 as a memorial to President Andrew Jackson. Tom Thumb gave three performances here when he visited the city in 1849 and President Zachary Taylor's inaugural ball was held here. When this photo was taken the building was being used as a rare seed warehouse by the Department of Agriculture. It was

torn down in 1949 to make room for the Federal Courthouse.

Above: **57. John Marshall Place, North to Old City Hall, 1890.** At the left is the Hotel Fritz Reuter. From 1834 to 1855 Mrs. Elizabeth Peyton ran her "select boarding house" here. Her guests included Chief Justice Marshall, Clay, Calhoun, Justice Story and other notables. The original building was later remodeled and occupied by the Hotel Fritz Reuter, noted for its German cooking and wines. To the right are the spires of the Metropolitan Church and the First Presbyterian Church.

Over: **58. Pennsylvania Avenue, NW, Looking East, ca. 1857.** This early photo, taken on the block between 3rd and 4th Streets, shows the first row of columns being put in place in the drum of the Capitol's dome.

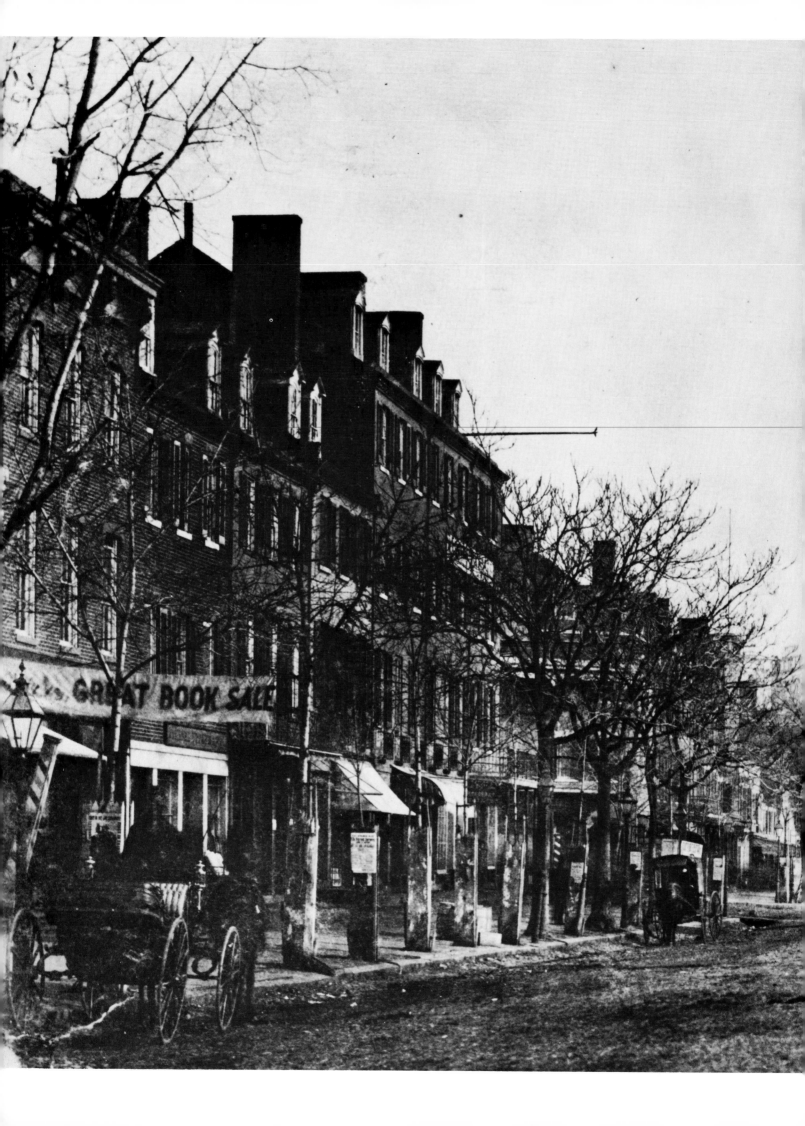

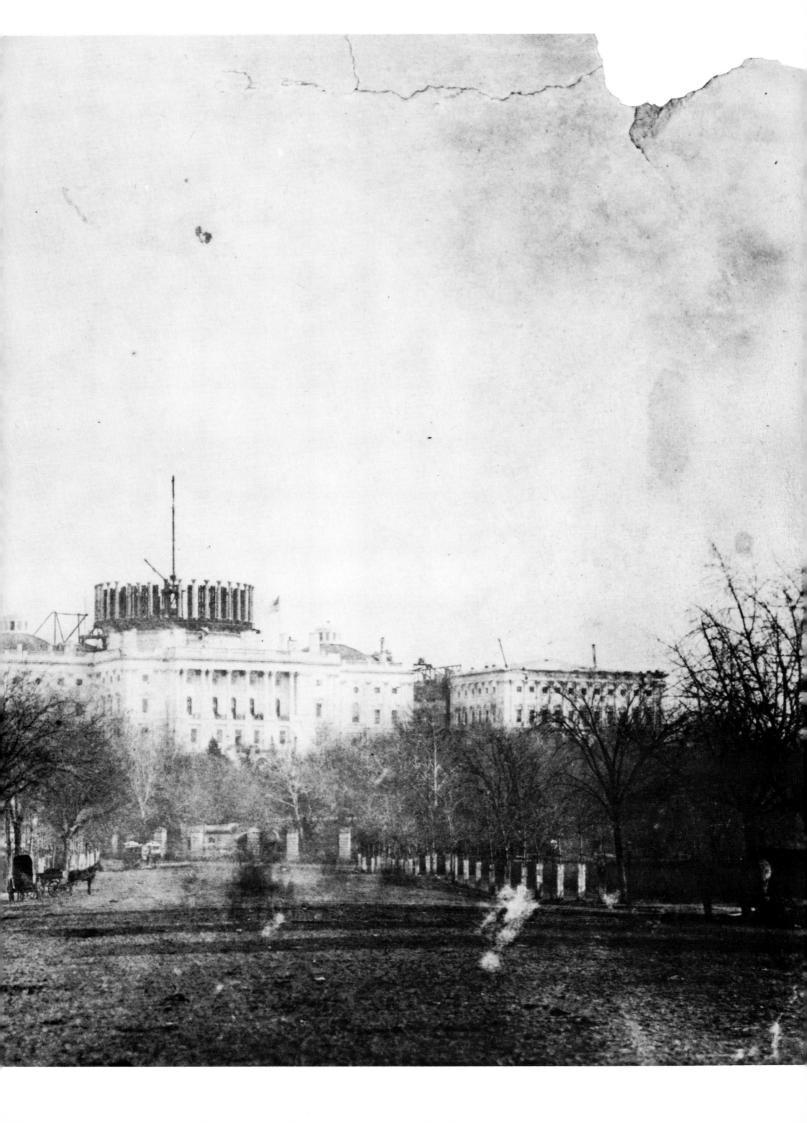

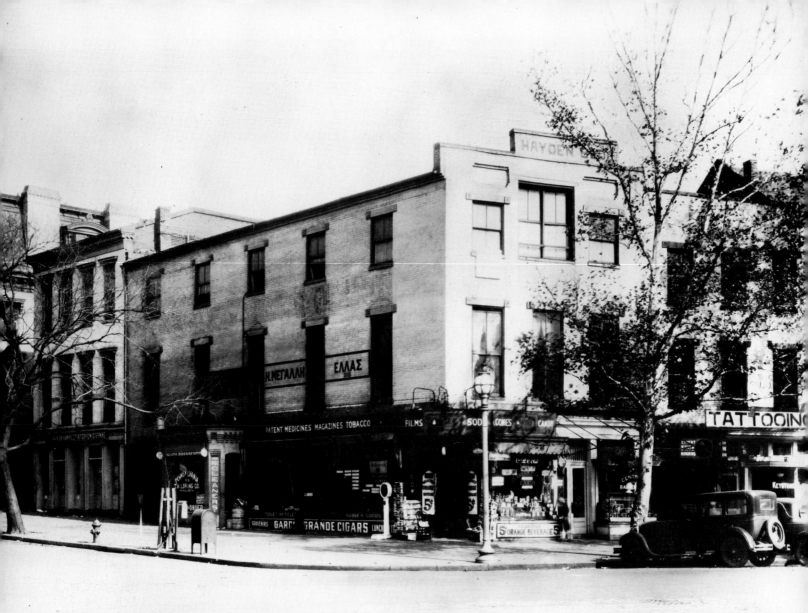

Above: **59. The Hayden Building, Pennsylvania Avenue, NW, and John Marshall Place, ca. 1922.** An early social hall, the Hayden Building had many historic associations.
Opposite: **60. The Gospel Mission, 214–18 John Marshall Place, NW, ca. 1915.** Founded in 1906, the Mission moved, in 1942, to 810 5th Street, NW, where it continues its activities.

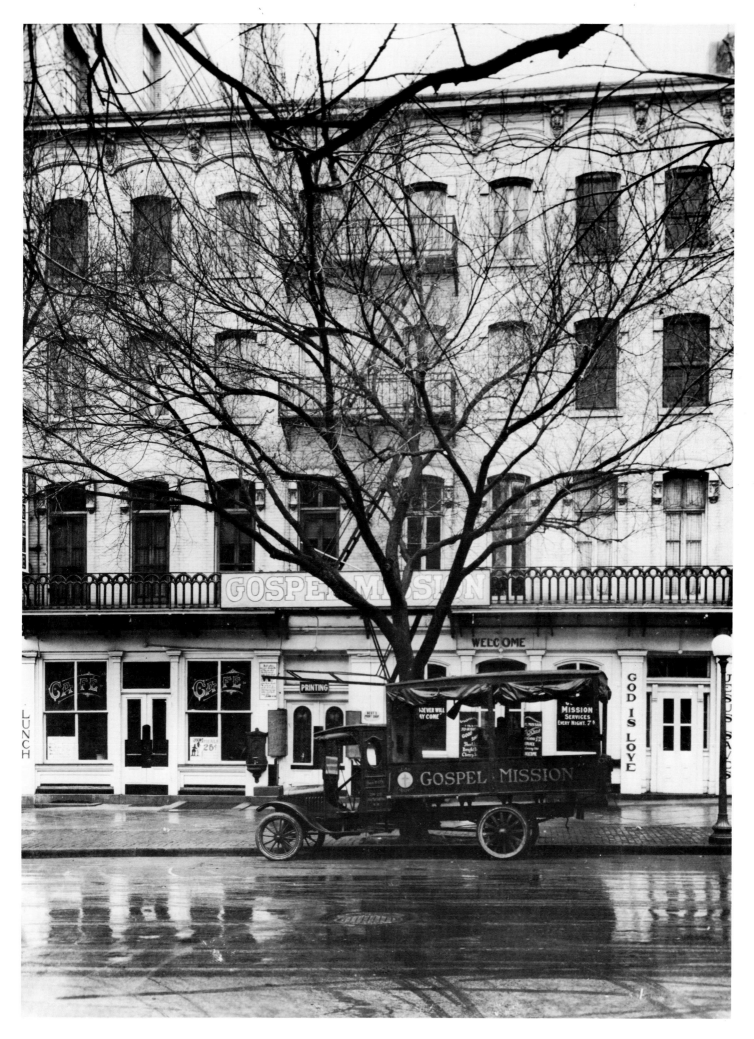

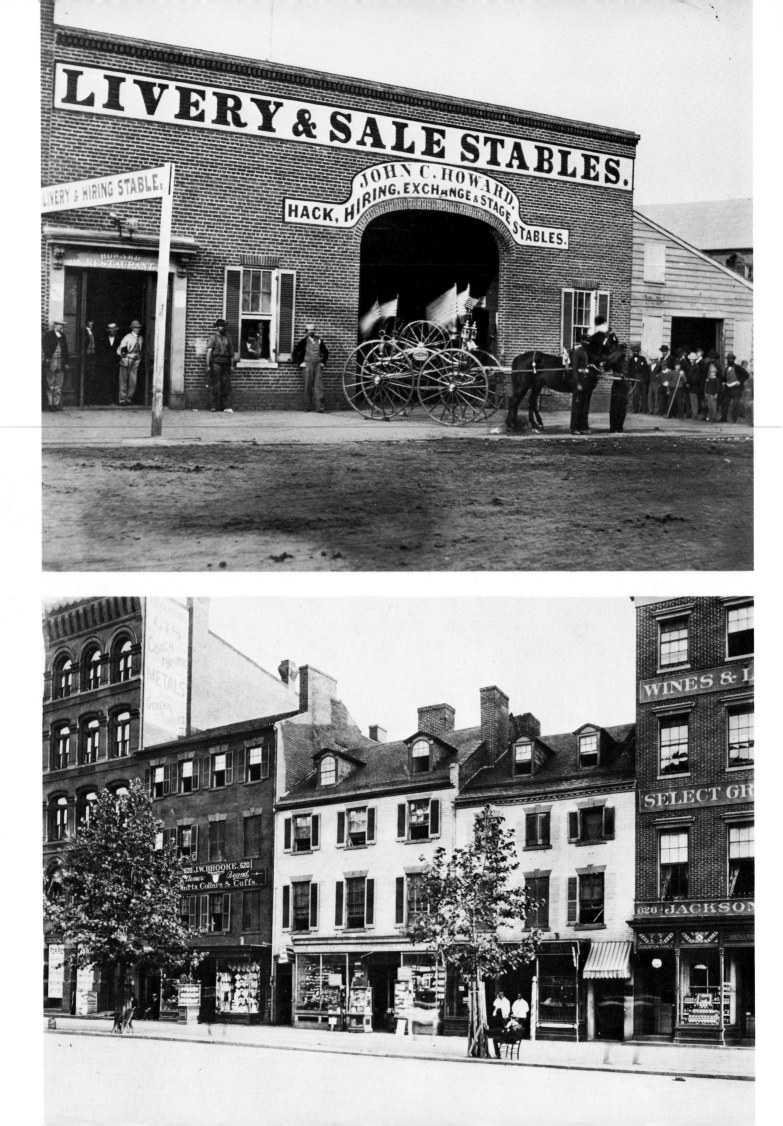

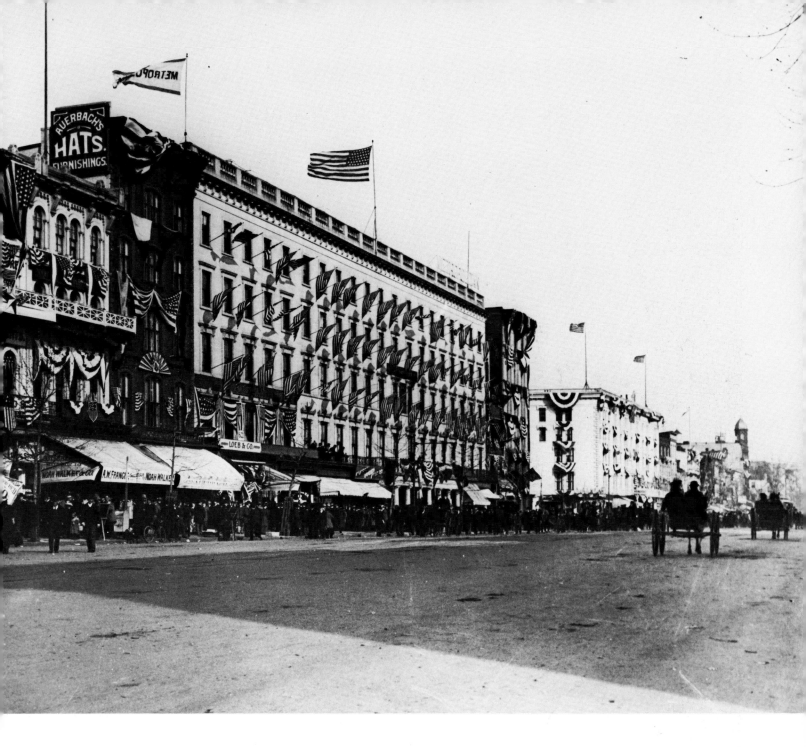

Opposite, top: **61. John C. Howard's Livery Stable and Saloon, Pennsylvania Avenue, near 6th Street, NW, 1865.** Out in front is a new hose reel belonging to the Northern Liberties Fire Company. It was here that John Wilkes Booth bought a horse after he shot President Lincoln. During the winter of 1864–65 Booth had rented a room in the National Hotel, just across the avenue.

Opposite, bottom: **62. Nos. 620–24 Pennsylvania Avenue, NW, July 18, 1902.** These three residences, demolished in 1928, dated from the early nineteenth century. Along this stretch of the avenue and its adjacent streets stood hotels,

boardinghouses and restaurants where statesmen lodged, dined and debated the issues of the day.

Above: **63. The Metropolitan Hotel, Pennsylvania Avenue, between 6th and 7th Streets, NW, ca. 1890.** Formerly the Indian Queen Hotel, the Metropolitan flourished as a well-known hostel from 1810 until the Civil War. It was the Washington home of many distinguished congressmen and visitors and the scene of spectacular inaugural balls and fiery political debates. Photographer Mathew Brady had his studio in the top three floors of Gilman's drugstore, far left, from 1858 until 1881.

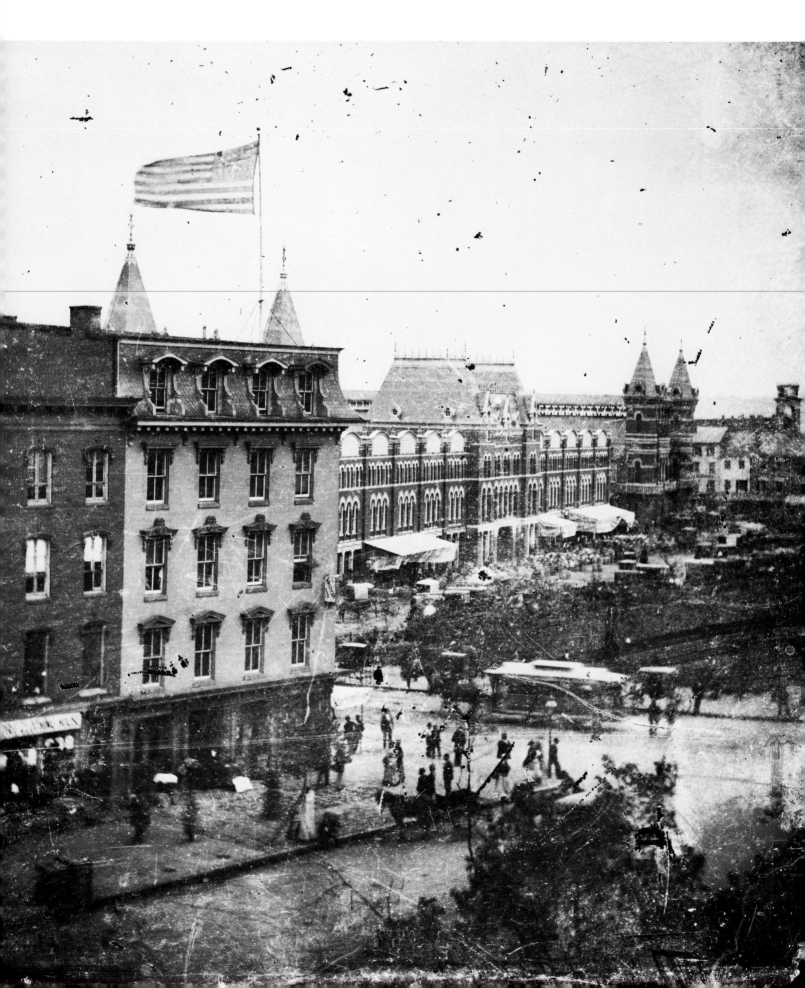

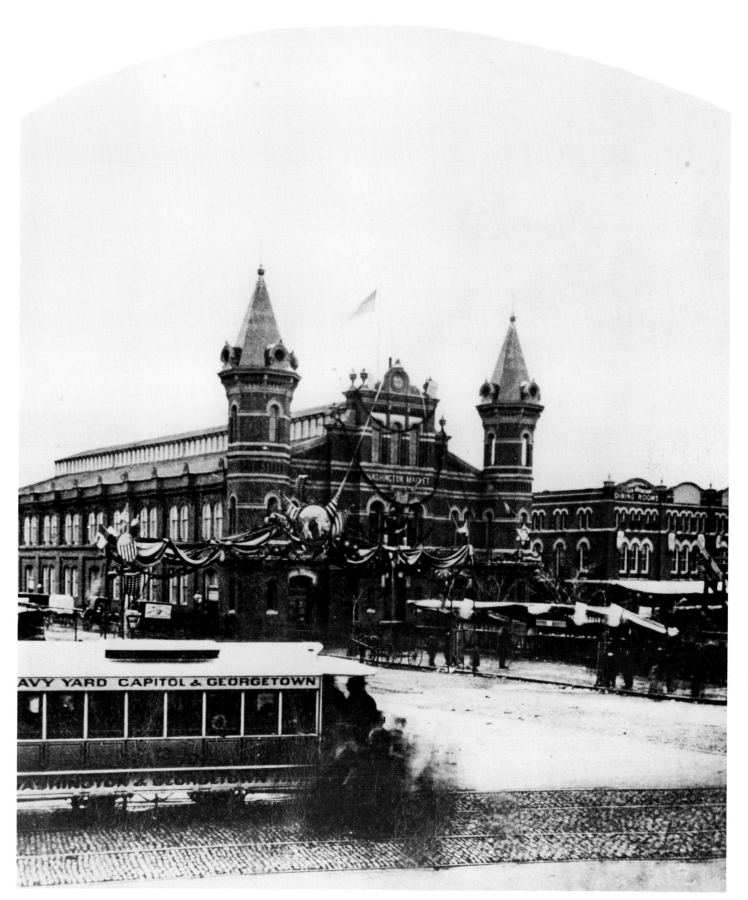

Opposite: **64. Center Market, 1882.** The market, seen in a view taken from Mathew Brady's studio, lay between 7th and 9th Street, NW, and from Pennsylvania Avenue to B Street (now Constitution Avenue). Almost everyone who lived in Washington went to Center Market the largest and liveliest in the city, for fresh meat, fruit, vegetables and dairy products. Organized at the beginning of the nineteenth century, it was at first no more than a small cluster of stalls and sheds where farmers came a day or two each week to sell their produce; permanent buildings were later erected and gradually other merchandise was offered for sale. It was demolished in 1931 to make way for the National Archives Building.

Above: **65. Center Market, 1881.** The market is decorated for President Garfield's inauguration.

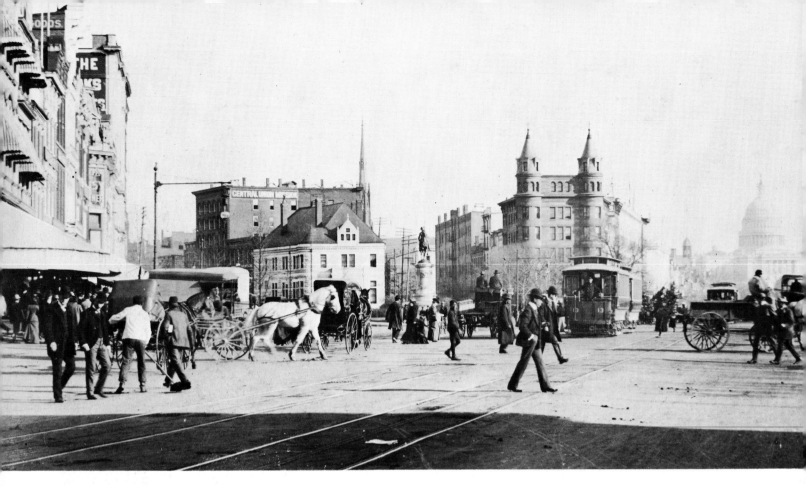
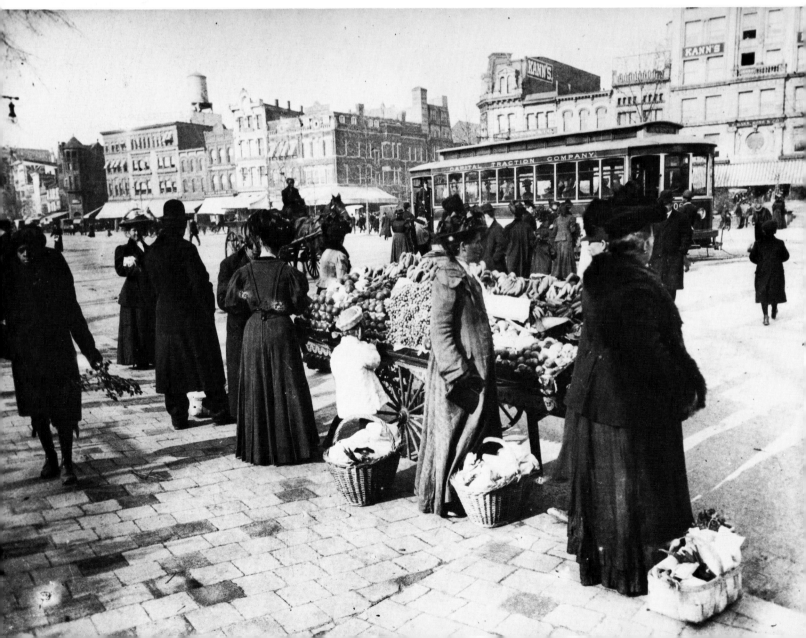

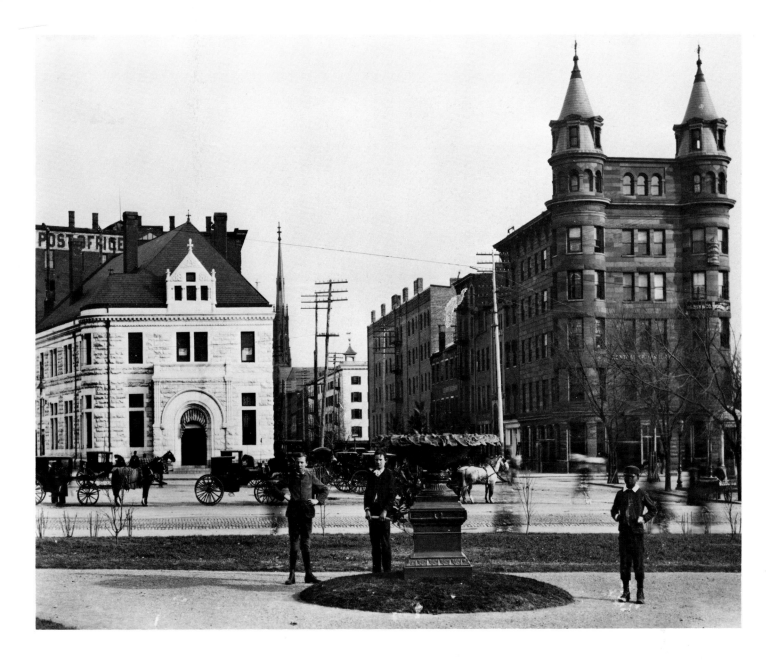

Opposite, top: **66. Market Square, ca. 1901.** A rather large plaza called Market Square extended along Pennsylvania Avenue from 7th to 9th Streets, NW. On the other side was Center Market. The north side, shown here, was the heart of the city's commercial district for much of the nineteenth century. In the center is the statue of General Winfield Scott Hancock by Henry Ellicott.

Opposite, bottom: **67. Market Square, South Side, Christmas, 1895.**
Above: **68. Market Square, East Side, 1890.** The principal buildings in this view down C Street, NW, from 7th Street are The National Bank of Washington on the left and the Central National Bank on the right.

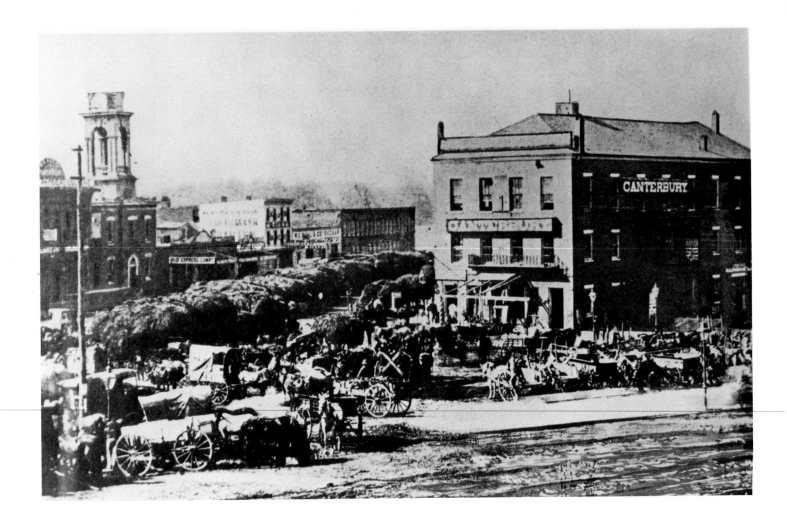

Above: **69. Haymarket Square, 1865.** The square stood at 9th Street and Louisiana (now Indiana) Avenue, NW, just west of Center Market. To the right is the Canterbury Theatre, dating from 1821. The building at the left with the tower is the Central Guard House. This site is now occupied by the Department of Justice.

Opposite, top left: **70. 7th Street, NW, just North of Market Square, 1881.** In the nineteenth century the department stores of the city were centered within a half dozen blocks of this area. There were four large department stores, several dime stores and a number of big furniture houses, as well as clothing, drug and notion stores. Painless dental emporiums offered extraction and bridgework on the easy payment plan. On the corner is the Corcoran Fire Insurance Company. The building with the large dome farther up the street is the Odd Fellows Hall.

Opposite, top right: **71. W. B. Moses Department Store, 7th Street and Market Space, ca. 1888.** The south side of Market Square was known as Market Space. Moses filled the sidewalk with his wares: rocking chairs, baby carriages, beds and wagons. To the left is M. Taylor & Co. dry goods merchant. Later stores to occupy this corner were Saks & Company and Kanns.

Opposite, bottom: **72. Dry Goods Row, Market Space, 1881.** Few of these architecturally interesting buildings remain today. The store at the left with the flag flying, 809 Market Space, is a rare survivor of the great period of Pennsylvania Avenue's commercial importance. This storefront presents a dramatic wall of windows accentuated with cast-iron Corinthian columns. A bold semicircular cornice bears the date of construction, 1868.

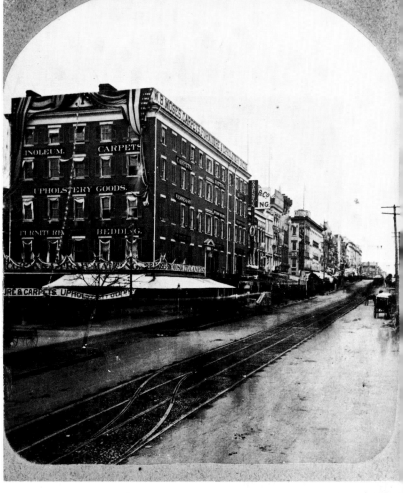

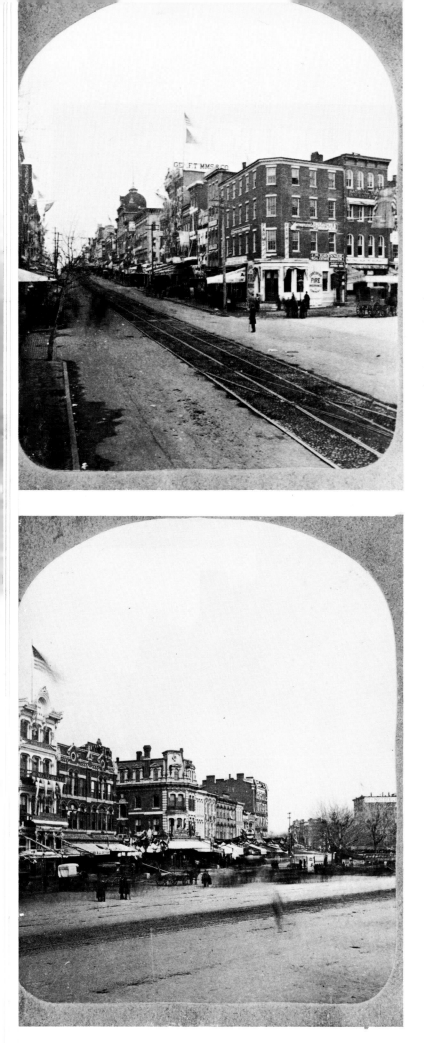

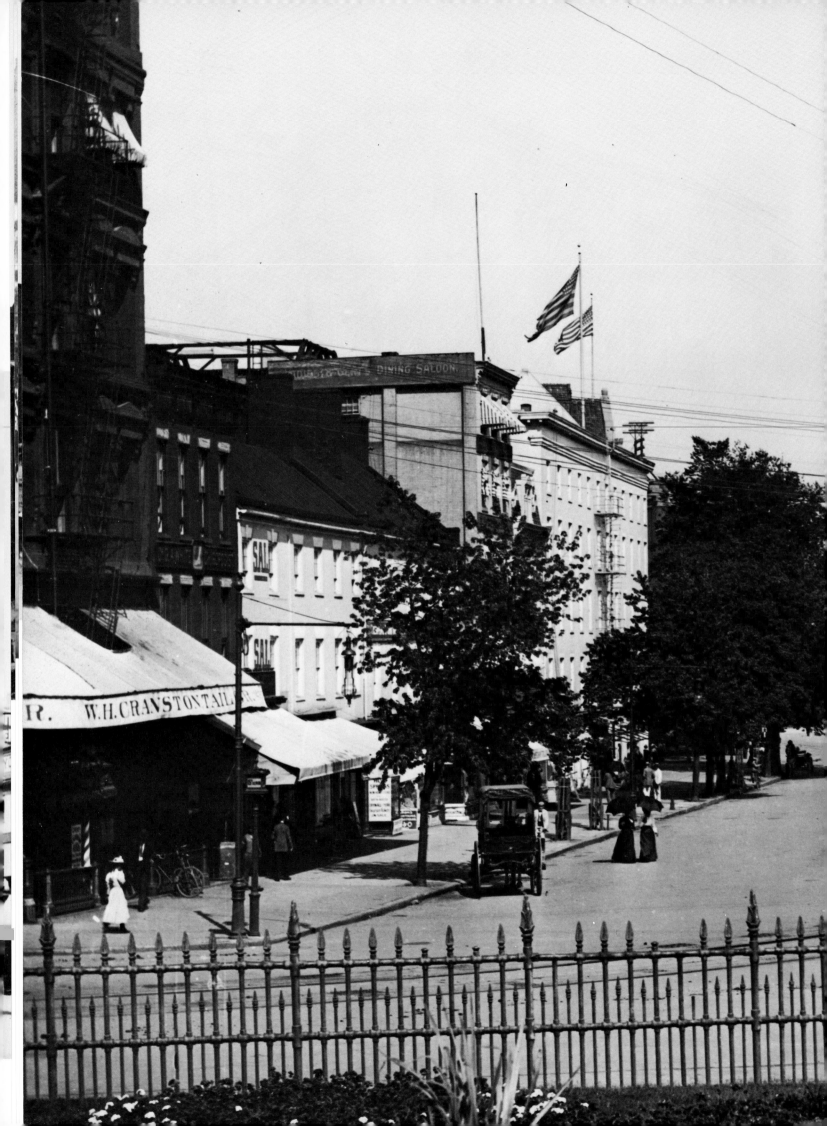

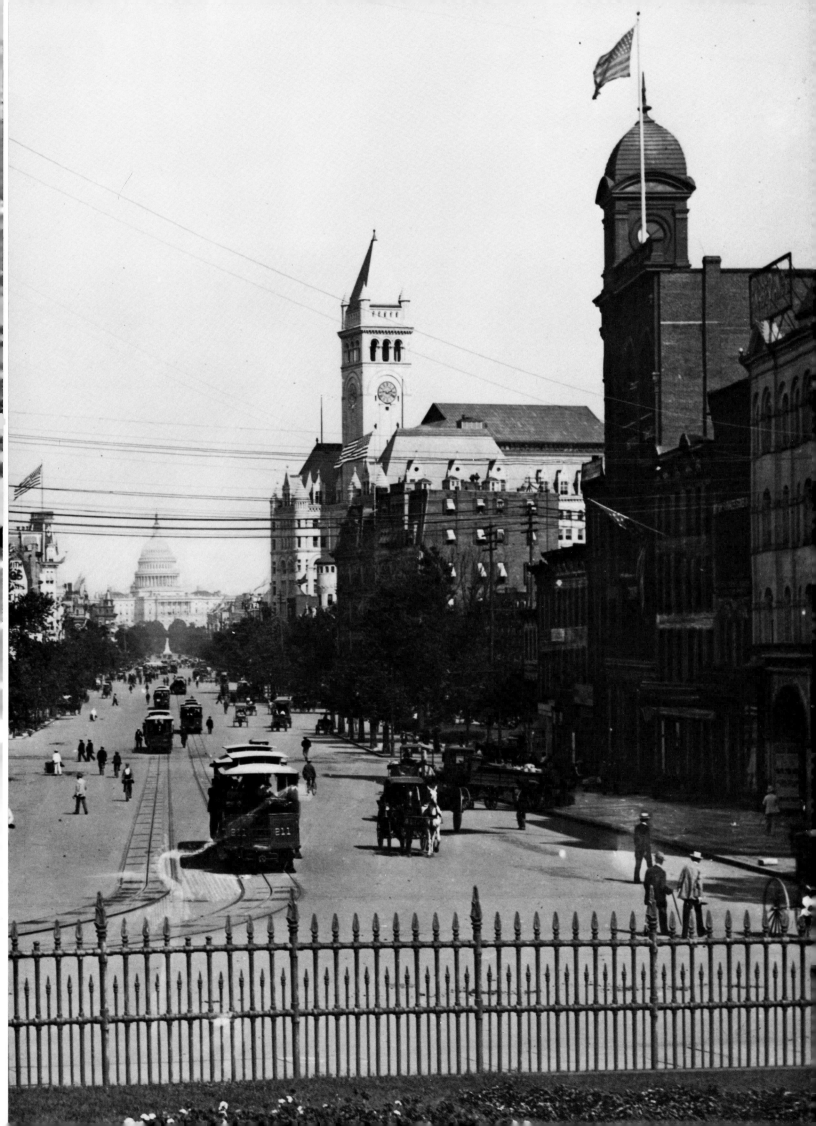

VIII.
C THROUGH K STREETS AND BEYOND

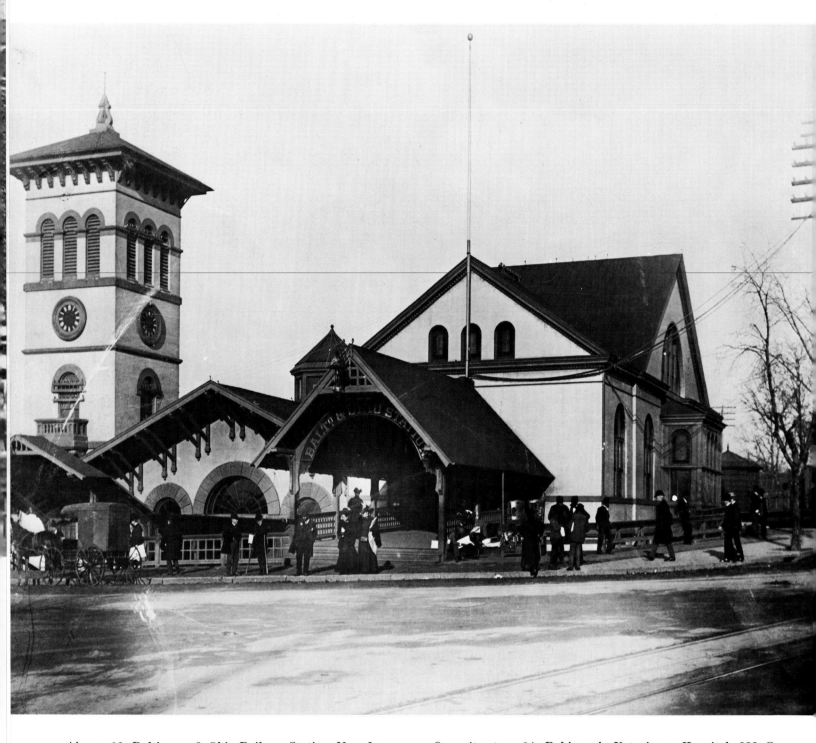

Above: **93. Baltimore & Ohio Railway Station, New Jersey Avenue and C Street, NW, 1888.** The B & O tracks ran to Washington as early as 1835, but trains were not allowed to enter the city under their own power. For 17 years trains halted on the outskirts of town and the cars were drawn into the city by horses. In 1852 the stricture was relaxed, and this Italianate station was erected three blocks north of the Capitol. The view shows the depot after extensive street grading had nearly buried the old station, at the left.

Opposite, top: **94. Robinson's Veterinary Hospital, 222 C Street, NW, ca. 1898.** Robinson's sons pose in the alley behind the hospital with the small ambulance that their father used to pick up sick and injured dogs and cats.
Opposite, bottom: **95. Capital News Company, 227 B Street (now Constitution Avenue), NW, ca. 1925.** The company was agent for *The Ladies' Home Journal, The Saturday Evening Post, Country Gentleman* and out-of-town newspapers. The view looks east from 3rd Street.

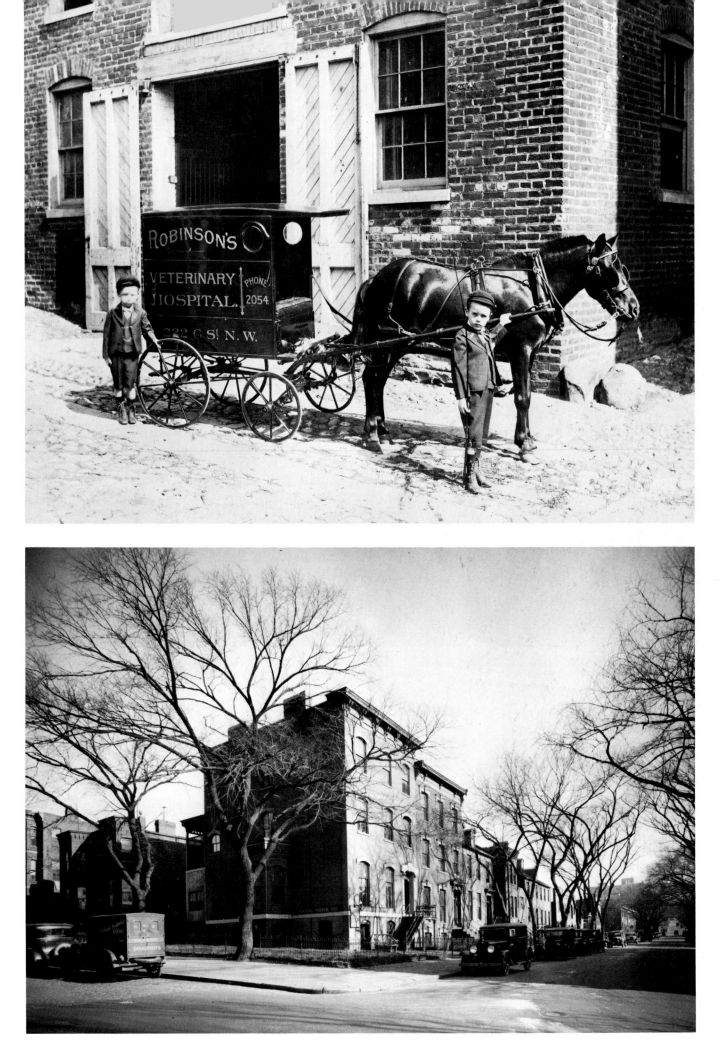

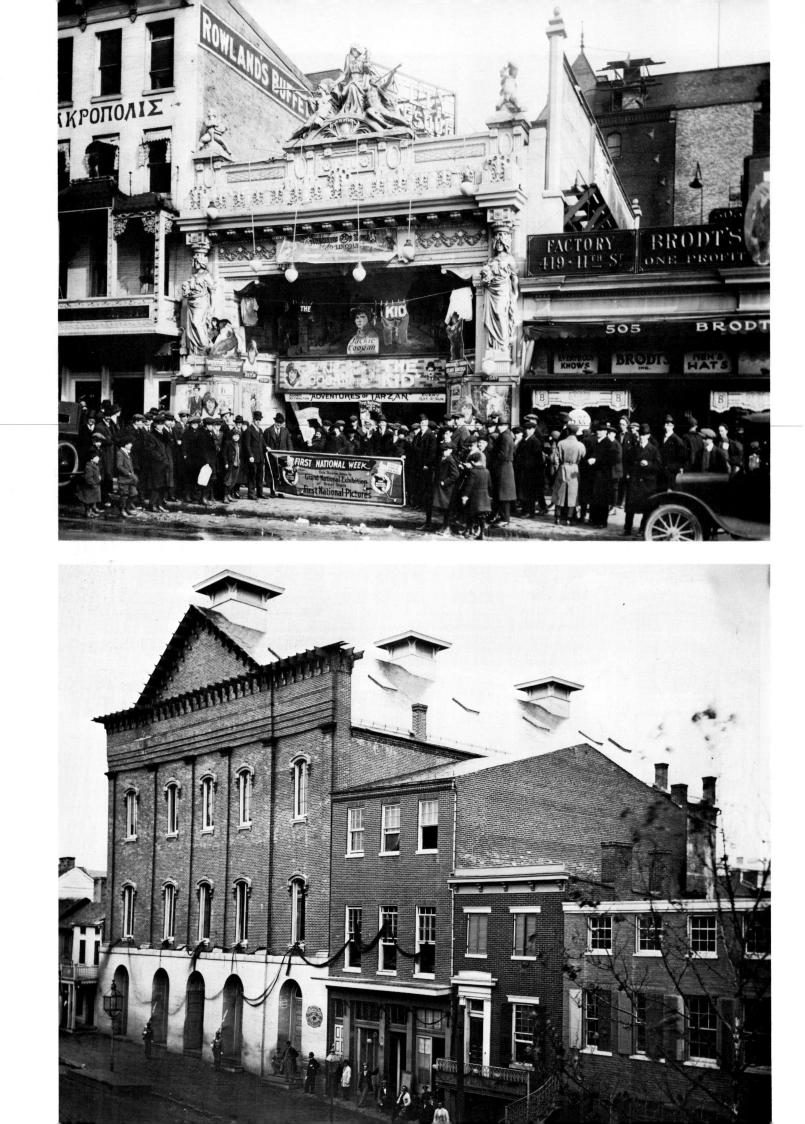

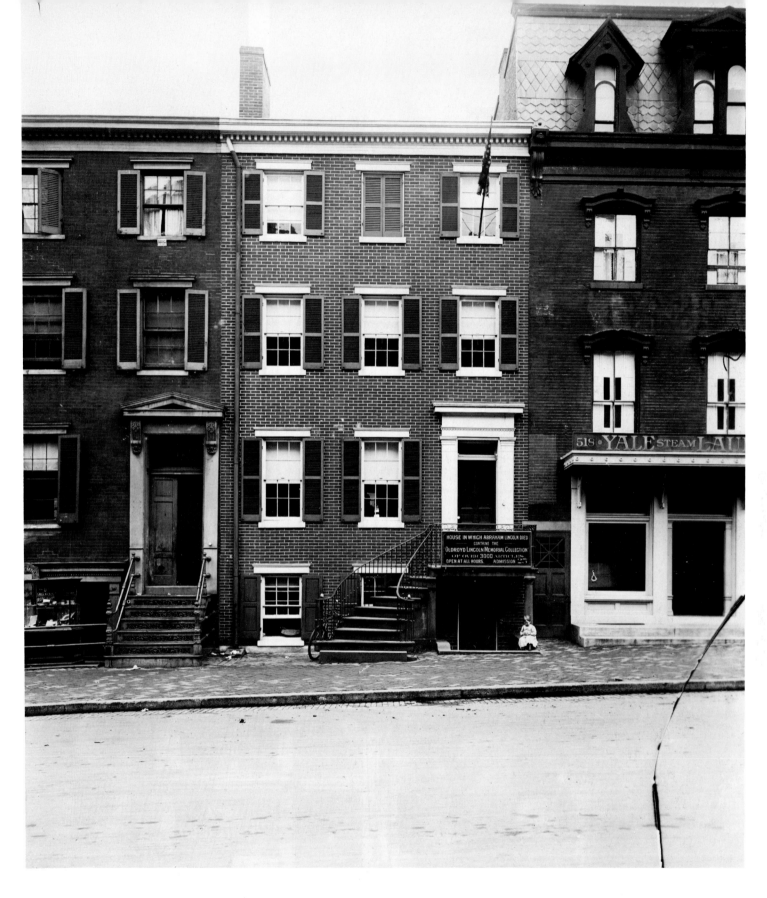

Opposite, top: **112. The Leader Theatre, 507 9th Street, NW, ca. 1922.** The movie house was built in 1910. Next door is the Acropolis, a Greek restaurant in the theater district.

Opposite, bottom: **113. Ford's Theatre, 511 10th Street, NW, April, 1865.** The theater and the Star Saloon next to it are draped in mourning following Lincoln's assassination on April 14. Thereafter the theater was closed and used as a government office building. In 1964 work was begun by the National Park Service to restore it to its 1865 appearance. It reopened in 1968 and has been used as a theater and Lincoln Museum since.

Above: **114. The Petersen House, 516 10th Street, NW, ca. 1894.** This typical Washington row house was built by William Petersen, a German-born tailor, in 1849, when this section of the city was a center for German Lutheran immigrants. Ford's Theatre is across the street, and when President Lincoln was shot there it was to the Petersen house that he was carried. He died there the next morning. Congress purchased the house in 1896, and it is open to the public.

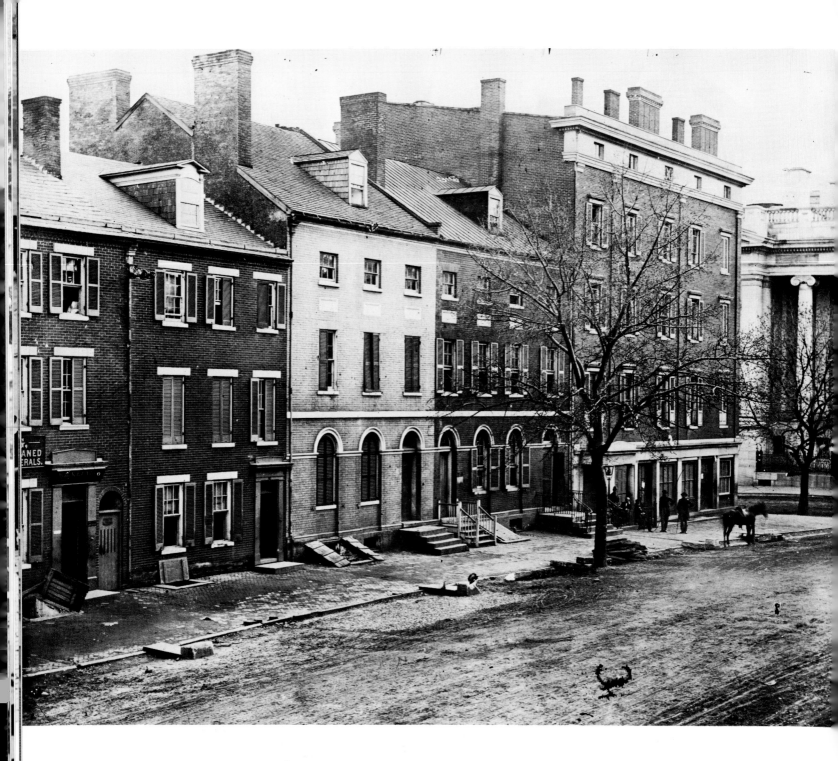

Above: **137. 15th and F Streets, NW, April, 1865.** Until well toward the close of the nineteenth century F Street between 1st and 15th Streets was a popular residential area. The corner building is on the site of the present Washington Hotel. The Treasury is to the right.

Opposite, top: **138. Rhodes Tavern, 15th and F Streets, NW, 1903.** The oldest commercial building remaining in downtown Washington, the tavern was built in 1801 directly opposite the Treasury. It served as the headquarters for the British officers directing the burning of the White House and the Treasury in 1814 and was also the first home of the firm which is now the Riggs Bank. Only the corner of the three-story building remains. The structure with flagpole to the left is the Citizens National Bank.

Opposite, bottom: **139. Old Pension Office, ca. 1900.** General Montgomery Meigs designed this massive structure on the block bounded by 4th, 5th, G and F Streets, NW, in the style of the Palazzo Farnese in Rome. Completed in 1885, it housed the army of clerks charged with disbursing pensions to Civil War veterans. The most outstanding feature of the building is an enormous covered interior courtyard, an incomparable setting for the inaugural balls of Presidents Cleveland, Harrison, McKinley, Theodore Roosevelt and Taft.

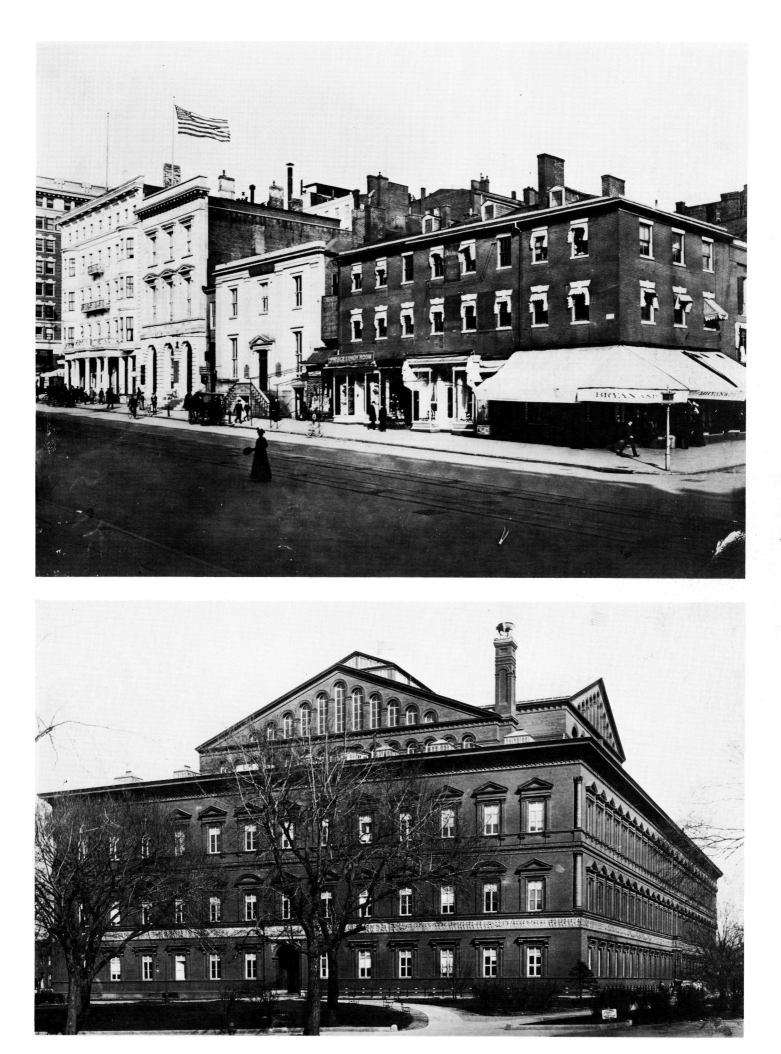

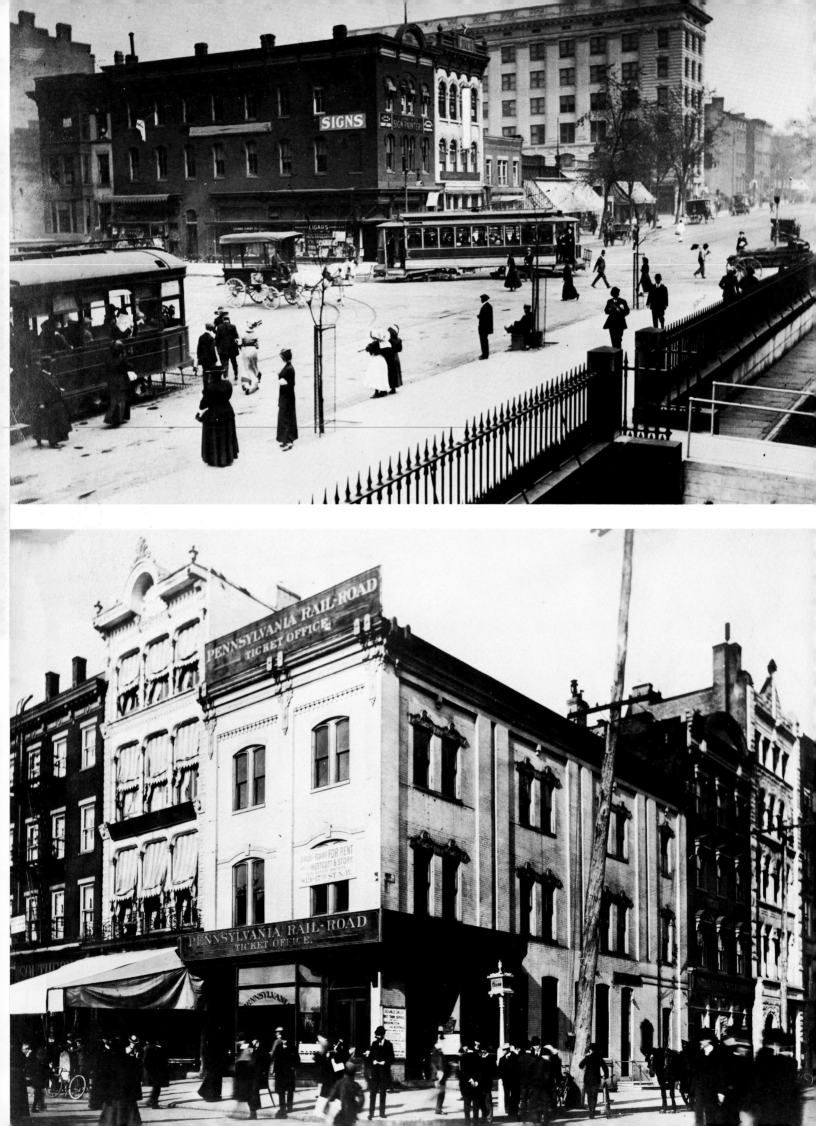

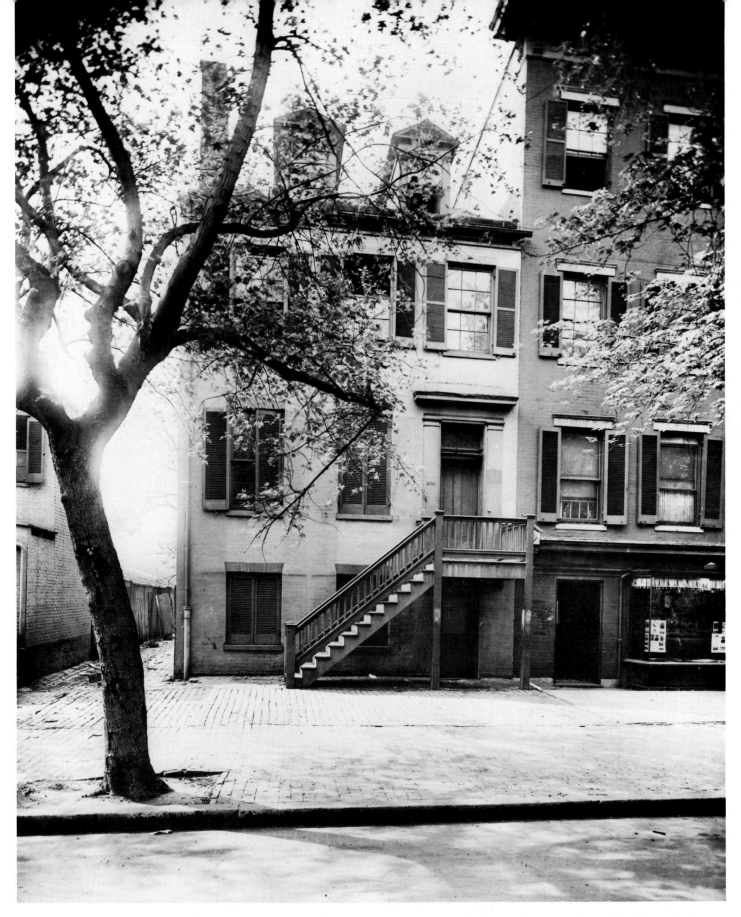

Opposite, top: **143. 9th and G Streets, NW, from the Patent Office, ca. 1912.** The corner is now the site of the Martin Luther King library.

Opposite, bottom: **144. Pennsylvania Railroad Ticket Office, 15th and G Streets, NW, April, 1914.** In the years of heavy rail travel, when competition for passengers was fierce, offices were opened in the heart of a city's commercial district for the convenience of patrons.

Above: **145. Mary Surratt House, 604 H Street, NW, ca. 1904.**

In this small, elegantly proportioned brick town house, now in the center of Washington's Chinatown, lived the unfortunate Mrs. Surratt, who was implicated in the plot to kill Abraham Lincoln. She was hanged July 9, 1865. In this building, where Chinese groceries and cooking wares are sold today, John Wilkes Booth is said to have discussed the assassination with Mrs. Surratt's son and some of her boarders.

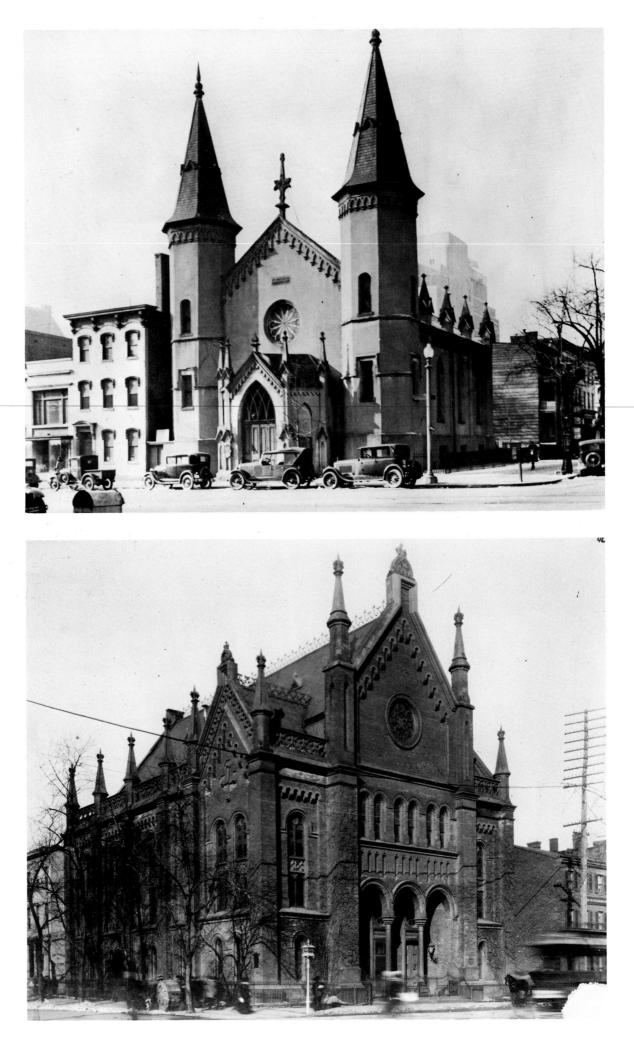

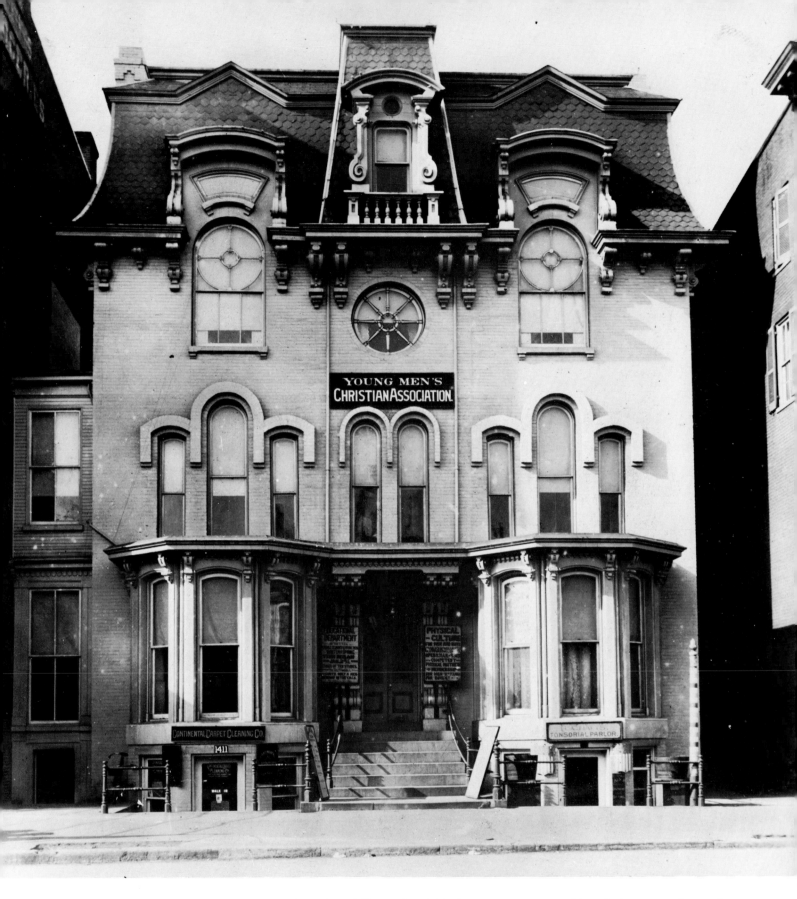

Opposite, top: **146. St. Paul's Lutheran Church, 11th and H Streets, NW, 1929.** The church was built in 1845 on ground donated by landowner General John P. VanNess. The site is now occupied by the general offices of the Washington Gas Light Company.

Opposite, bottom: **147. Foundry Methodist Church, 14th and G Streets, NW, 1902.** The original church was built in 1815 on land given by Henry Foxall as thanks for the preservation of his cannon foundry in the War of 1812. This elaborate brick church was built on the same site in 1866.

In 1902 the property was sold and the proceeds used to buy the present location of the church at 1500 16th Street, NW.

Above: **148. YMCA, 1411 New York Avenue, NW, ca. 1898.** The old Washington "Y" occupied a former mansion not far from H Street. Signs alongside the doorway advertise educational and physical-culture courses. Two businesses operate in the English basement: a carpet-cleaning company and a barber shop.

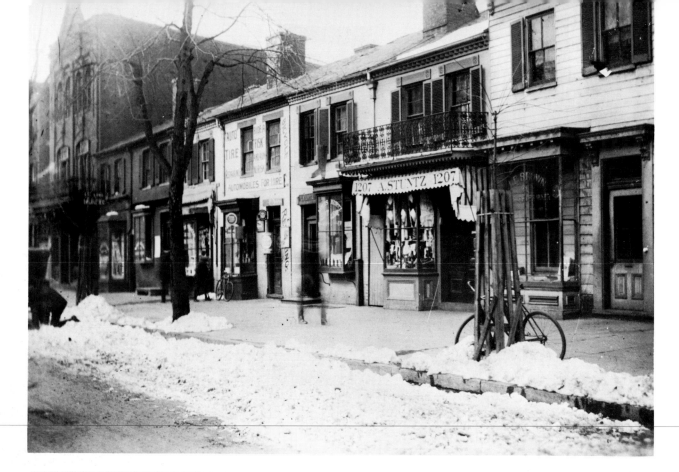

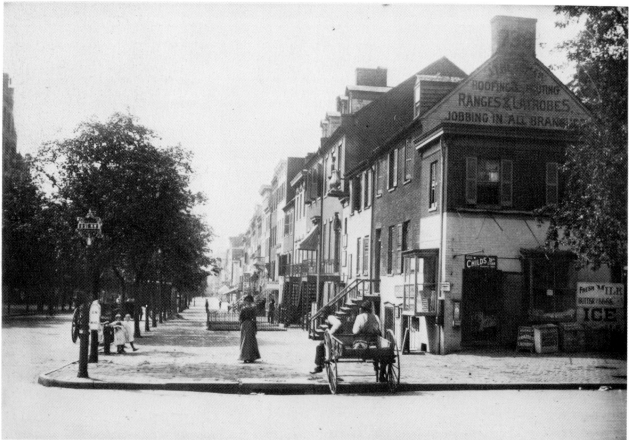

Above, top: **149. Joseph and Appolonia Stuntz's Toy Shop, 1207 New York Avenue, NW, ca. 1890.** It was in this little shop just off H Street that Abraham Lincoln bought toys for his son Tad. To the right is Brown's Shoe Store. To the left, with a sign shaped like a boot, is the shop of Louis Kurtz, shoemaker.

Above, bottom: **150. 13th and H Streets, NW, ca. 1906.** The corner house, 736 13th Street, is occupied by James T.

Henshaw and Company. In the penthouse is a small grocery. The adjacent house on 13th Street has a coffeepot sign over its doorway.

Opposite: **151. The Shoreham Hotel, ca. 1895.** The old Shoreham, from which the present hotel on Calvert Street derives its name, stood for forty years on the northwest corner of 15th and H Streets, NW.

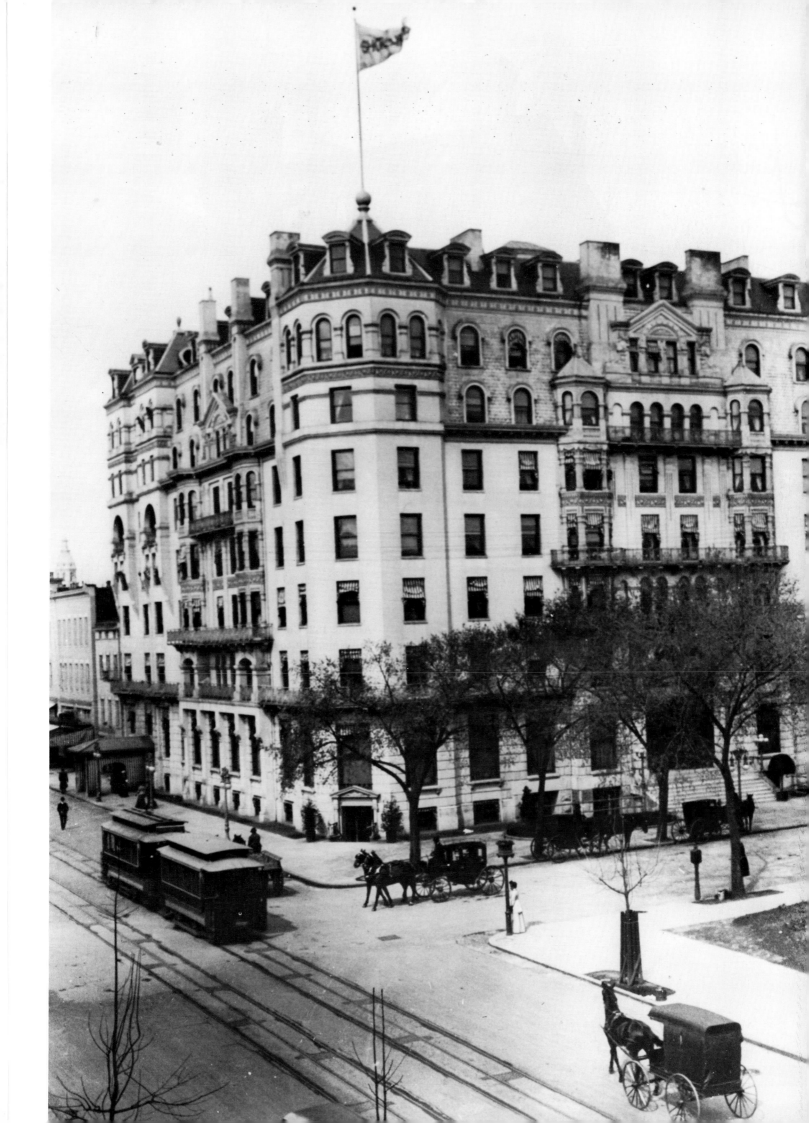

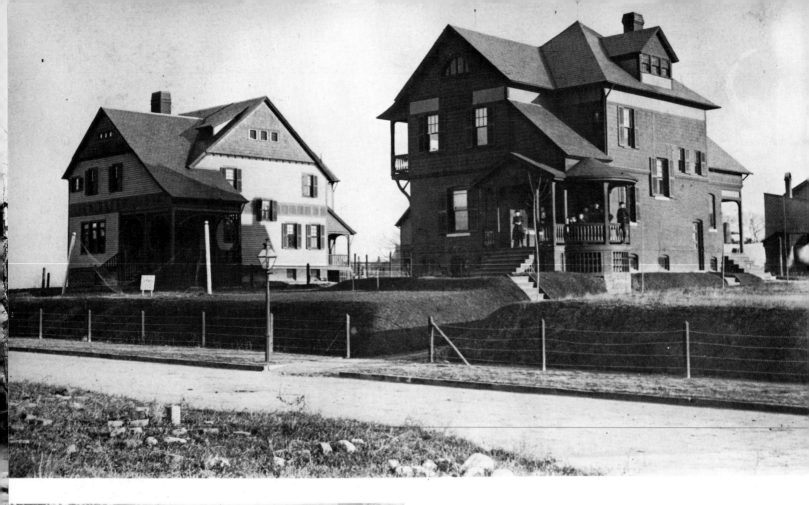

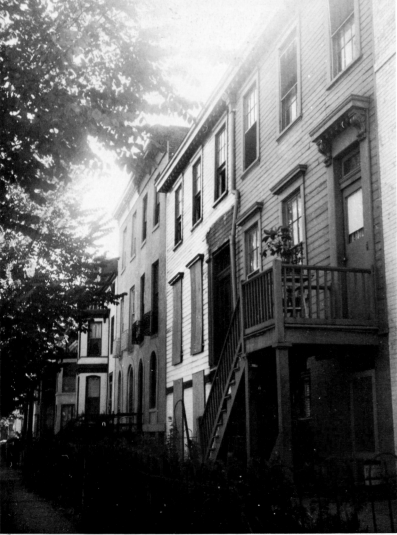

Above: 156. **Newly Built Queen Anne Cottages near 14th and Euclid Streets, NW, ca. 1889.**

Left: 157. **The 900 Block, M Street, NW, ca. 1920.** In this view the Victorian houses have fallen on hard times. The block was demolished in 1965.

Opposite, top: 158. **Schoolchildren, 10th and P Streets, NW, 1889.** At a box not far from fashionable Logan Circle, schoolchildren in starched white cotton blouses and dresses, knickers, straw hats and high buttoned shoes learn how to mail letters.

Opposite, bottom: 159. **Washington City Orphan Asylum, 14th and S Streets, NW, 1866.** The Italianate building was borrowed soon after its completion in 1866 by the State Department, which occupied it until October 1875.

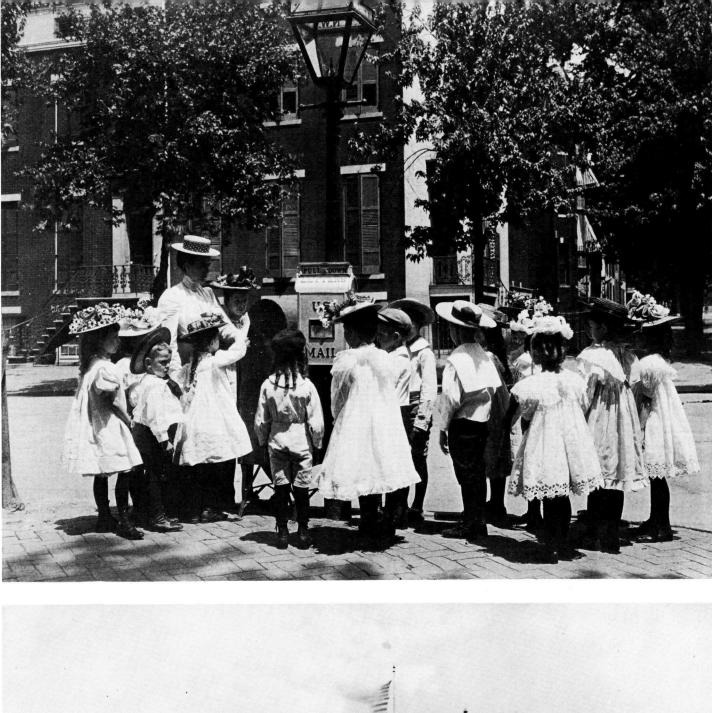

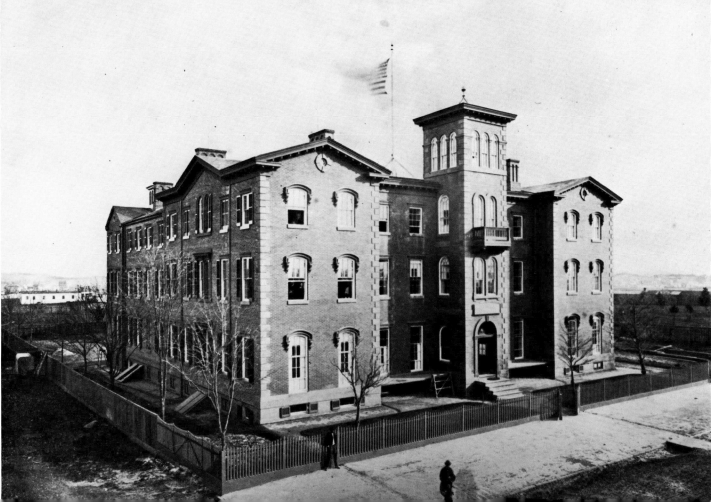

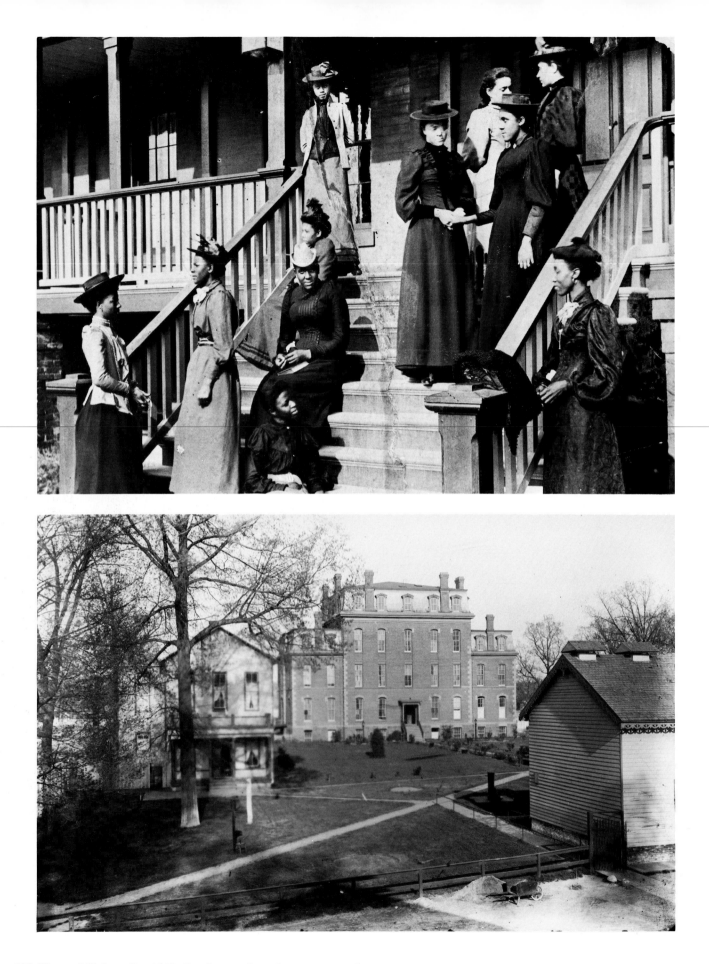

Top: **160. Howard University, 1893.** Coeds stand on the steps of Miner Hall Dormitory. Howard was founded by the federal government in 1867 as a school for Black men and women. It is named after Civil War General Oliver Otis Howard, who was its first president, holding the office from 1869 until 1874.

Bottom: **161. Medical School Building, Howard University, 5th and W Streets, NW, ca. 1870.** The building and its infirmaries are shown in a rear view.

IX.

THE WHITE HOUSE
AND LAFAYETTE SQUARE

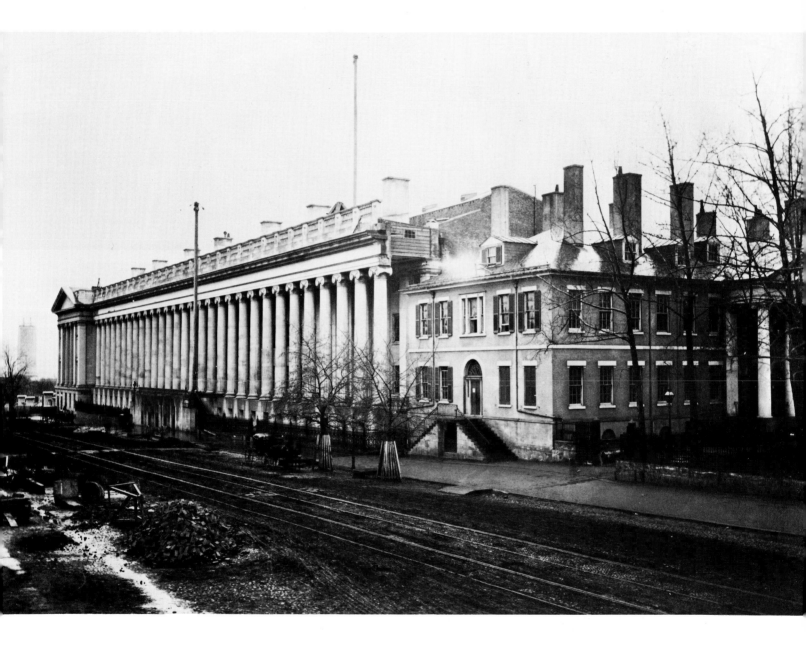

162. The Treasury and Old Department of State Buildings, 15th Street and Pennsylvania Avenue, NW, ca. 1862. The Treasury (left) is the third-oldest building in the city (the White House and the Capitol being earlier). This view shows Robert Mills's monumental Ionic colonnade, begun in 1836. In the distance at the far left is the unfinished Washington Monument.

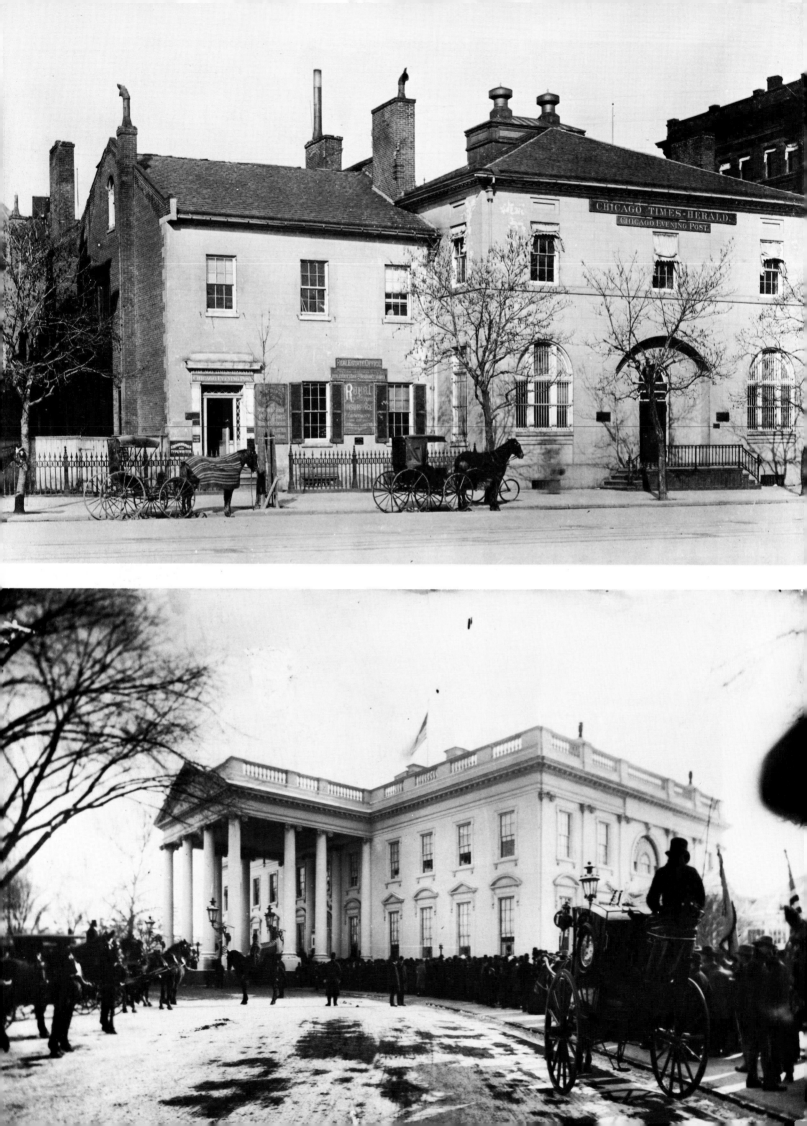

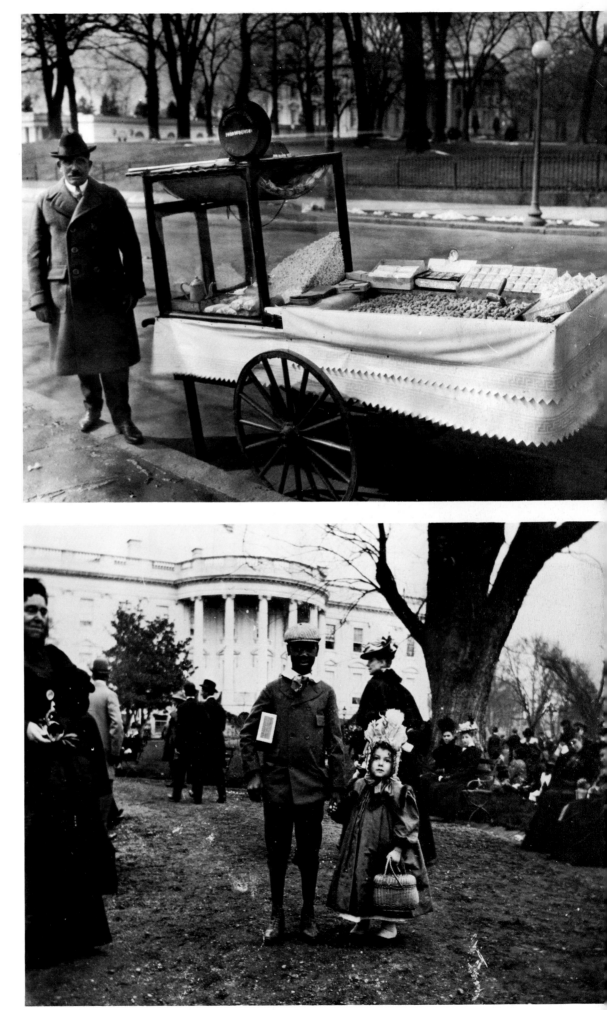

Opposite, top: **166. The Branch Bank of the United States and the W. W. Corcoran Office Building, ca. 1890.** The structures, both at 1503 Pennsylvania Avenue, NW, were designed by George Hadfield and built in 1824. Newspapers and commercial firms rented part of each building. The cashier's house (left) was torn down in 1900 and the corner building (right) in 1904. The site is now occupied by the American Security and Trust Bank and Riggs Bank.

Opposite, bottom: **167. The White House, 1600 Pennsylvania Avenue, NW, 1902.** Crowds wait in line for President Theodore Roosevelt's New Year's Day reception. This view shows the White House just a few months before it was extensively remodeled and enlarged.

Right, top: **168. Steve Vaselake, March 9, 1923.** The vendor of roasted peanuts and popcorn poses at his stand on East Executive Avenue, NW, across the street from the White House.

Right, bottom: **169. The White House Grounds, Easter Monday, 1898.** A child makes ready for the traditional egg-rolling ceremony.

Over: **170. The South Lawn, ca. 1902.** A Saturday afternoon crowd listens to a Marine Band concert.

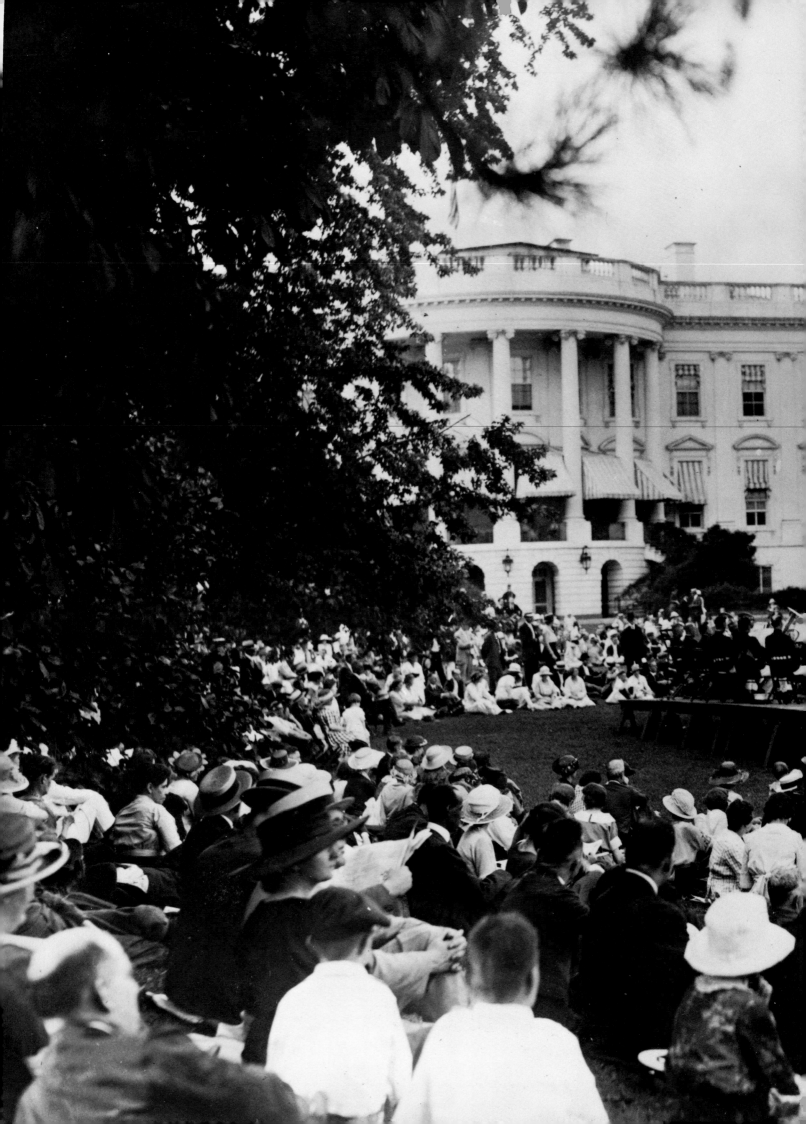

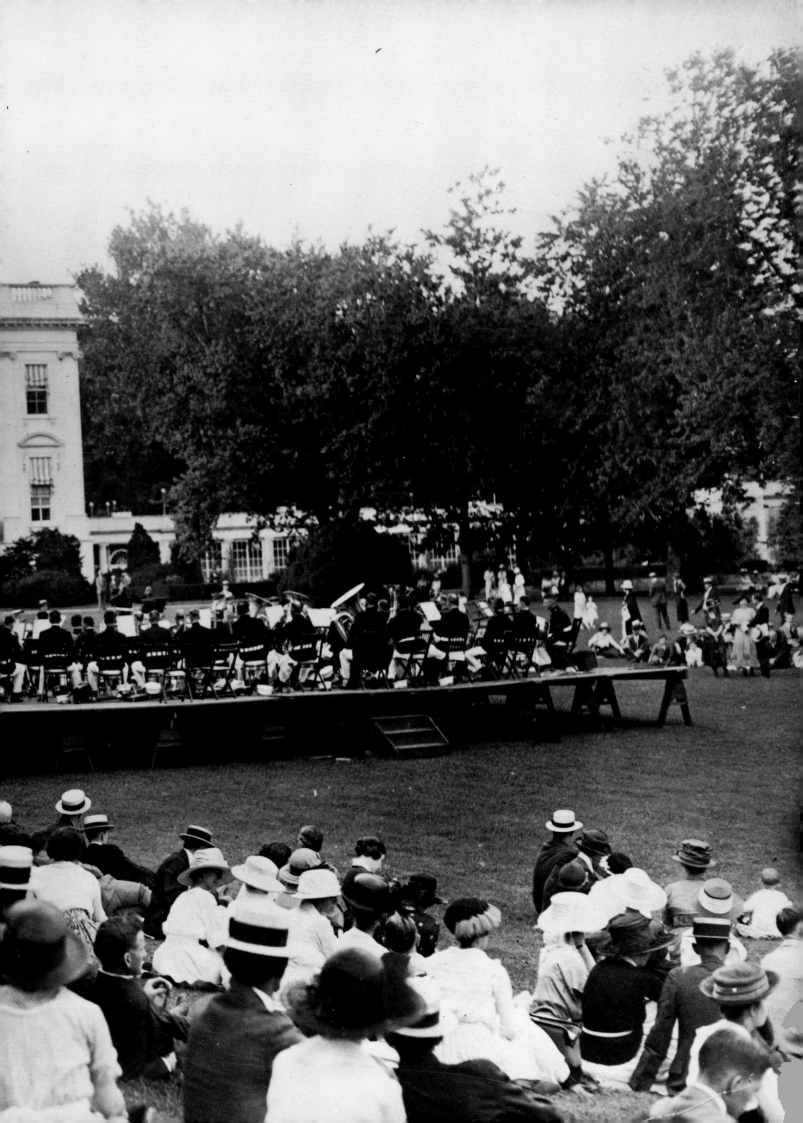

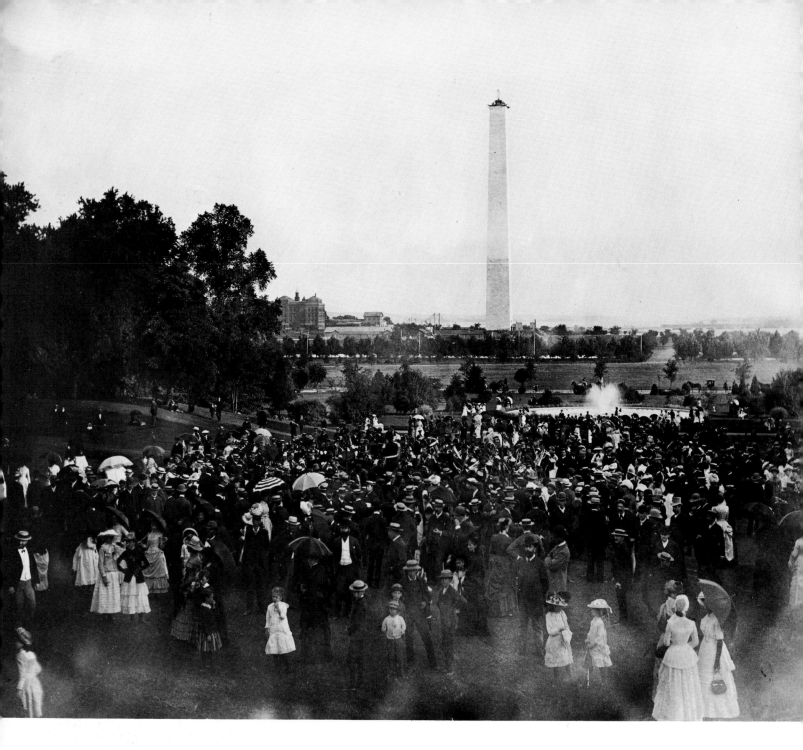

Above: **171. The White House Grounds, 1883.** A summer crowd mingles on the grounds during Chester Arthur's administration, a year before the capstone was finally put in place on the Washington Monument. Left of center, visible beyond the trees, is the Bureau of Printing and Engraving. The Tidal Basin is in the background.

Opposite, top: **172. The State, War and Navy Building, Pennsylvania Avenue and 17th Street, NW, 1897.** Now known as the Executive Office Building, the colossal structure containing 550 rooms was designed by Alfred B. Mullet and built between 1871 and 1888. Its style—French Second Empire, more popularly called "General Grant"—has been controversial ever since it was completed. There were once serious proposals to cover it with a classical curtain wall to match the Treasury.

Opposite, bottom: **173. Pennsylvania Avenue, NW, March, 1905.** Reviewing stands have been set up for the parade at Theodore Roosevelt's second inauguration. In the center are the old Corcoran Gallery of Art and Blair House.

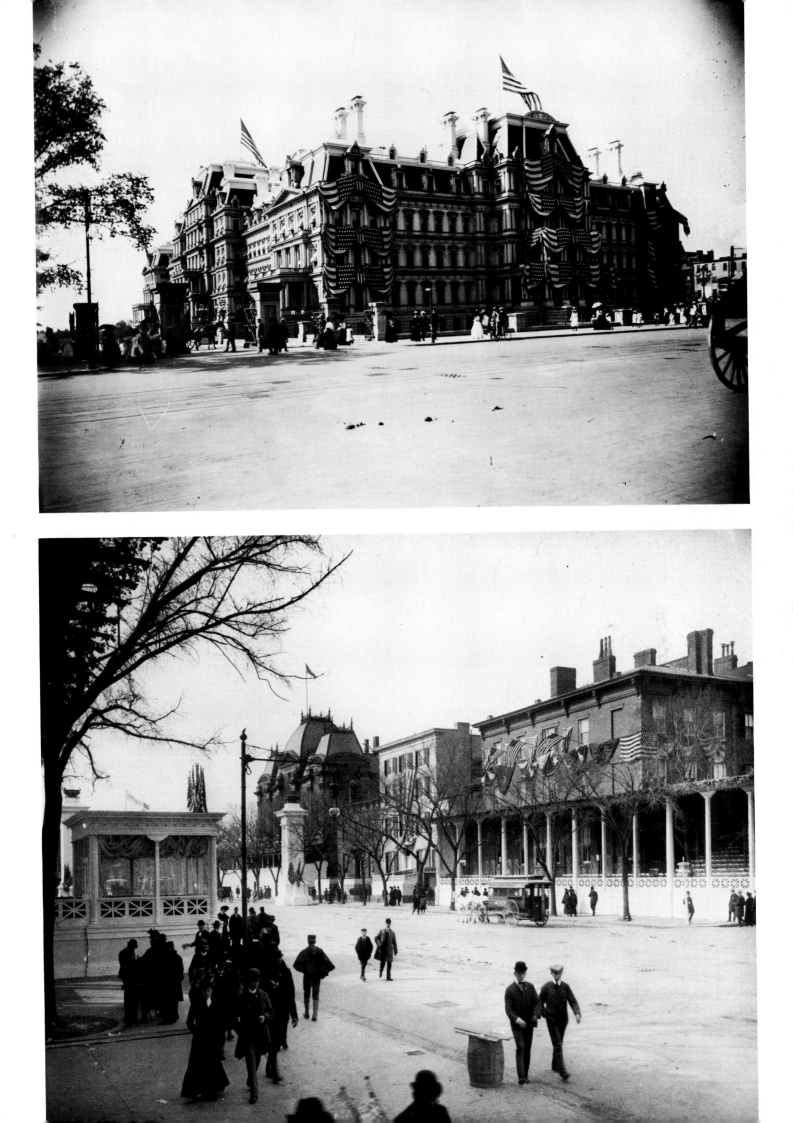

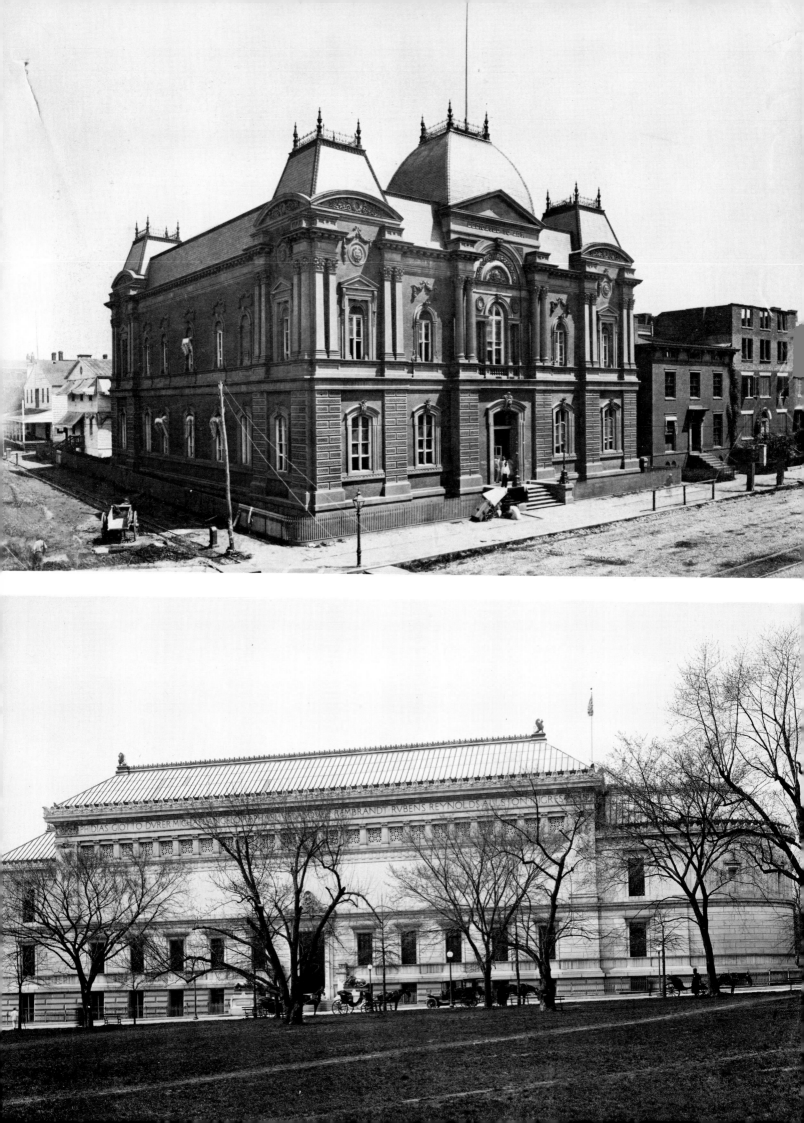

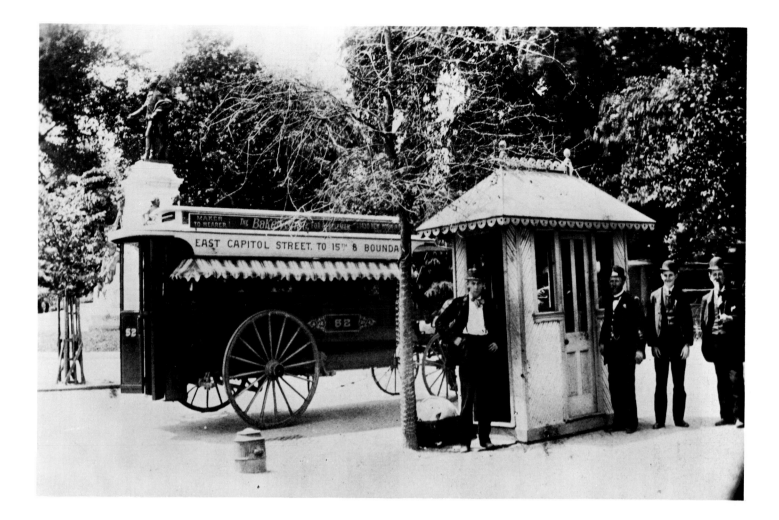

Opposite, top: **174. The Old Corcoran Gallery of Art, ca. 1859.** This rare early photograph shows the gallery nearing completion at the northeast corner of 17th Street and Pennsylvania Avenue, NW. The architect was James Renwick, who also designed the Smithsonian Building. The Civil War broke out before the gallery was finished and the building was borrowed by the government for use as a warehouse. After the war it was completed and opened to the public in 1874. In 1971 the building was completely restored and renamed the Renwick Gallery as part of the Smithsonian Institution. To the right is Blair House, having a third and fourth story added to the original two of 1824. Blair House and the adjacent Lee House have been official government guest houses for visiting dignitaries since the 1940s.

Opposite, bottom: **175. The New Corcoran Gallery of Art, 17th Street and New York Avenue, NW, ca. 1915.** In 1897, when the collection had outgrown the old gallery, this new structure, designed by Ernest Flagg, was erected facing the White House gardens.

Above: **176. Waiting Station, Lafayette Square, 1891.** The horse-drawn omnibuses of the Herdic Phaeton Company stopped at this gingerbread waiting station.

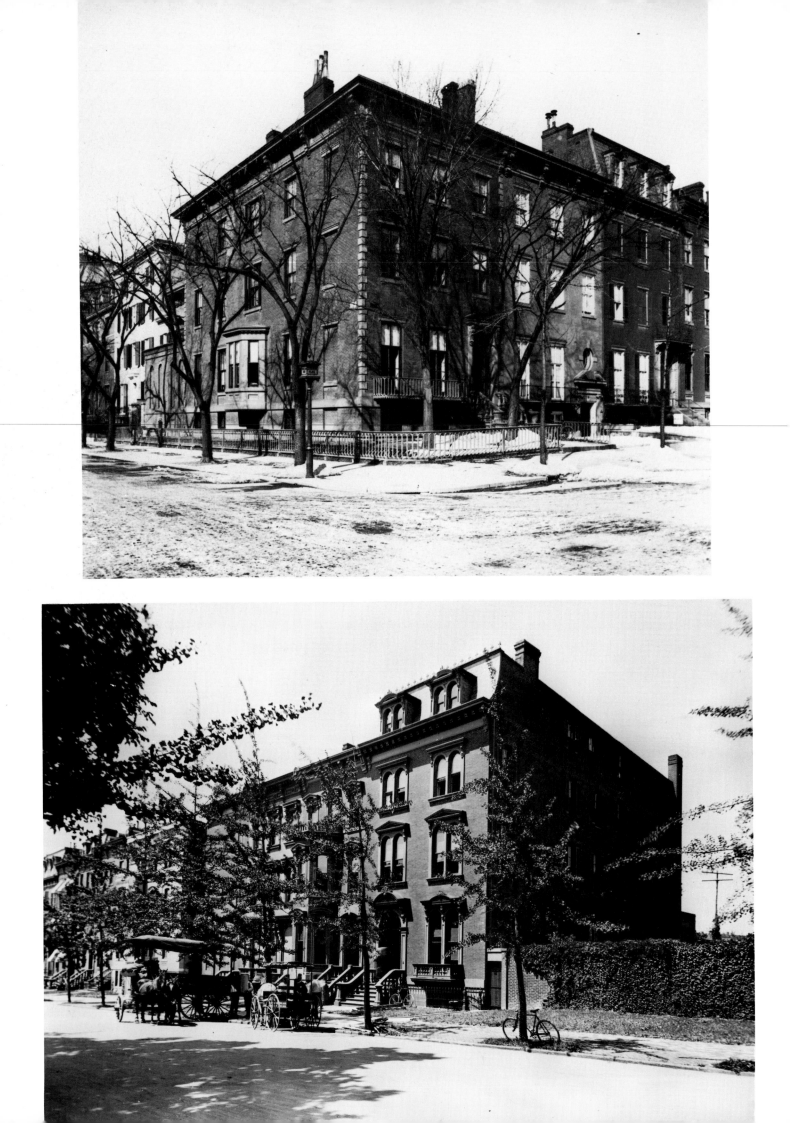

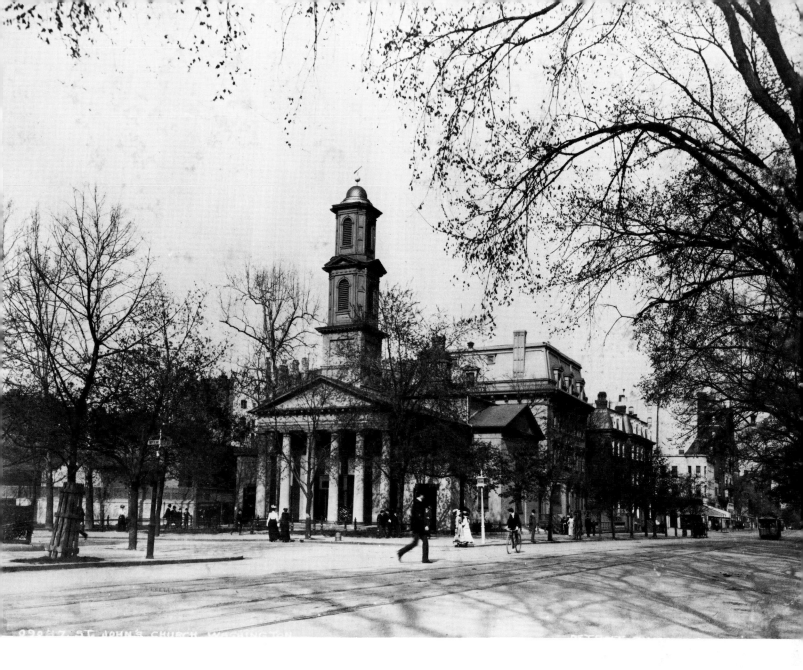

Opposite, top: **177. Town Houses, Jackson Place and Pennsylvania Avenue, NW, ca. 1920.** The corner house was occupied by the Carnegie Endowment for International Peace for many years until the late 1960s, when the properties around Lafayette Street were redeveloped. The old dwelling is now an annex of Blair House, which is shown at the left. The third house from the corner, at the right, 708 Jackson Place, is headquarters for the Commission of Fine Arts.

Opposite, bottom: **178. No. 736 Jackson Place, NW, 1902.** Workmen move the belongings of the Roosevelt family to this house on the west side of Lafayette Square at the beginning of renovations to the executive mansion. This was the temporary White House from June 25 to November 6.

Above: **179. St. John's Episcopal Church, 16th and H Streets, NW, ca. 1906.** Benjamin Latrobe designed the church in 1816. It has undergone numerous architectural changes since. Over the years so many presidents have worshipped here that it is unofficially known as the Church of the Presidents. The four-story, mansard-roofed house to the right of the church, 1525 H Street, is the old British Legation, built in 1822, now the church parish hall.

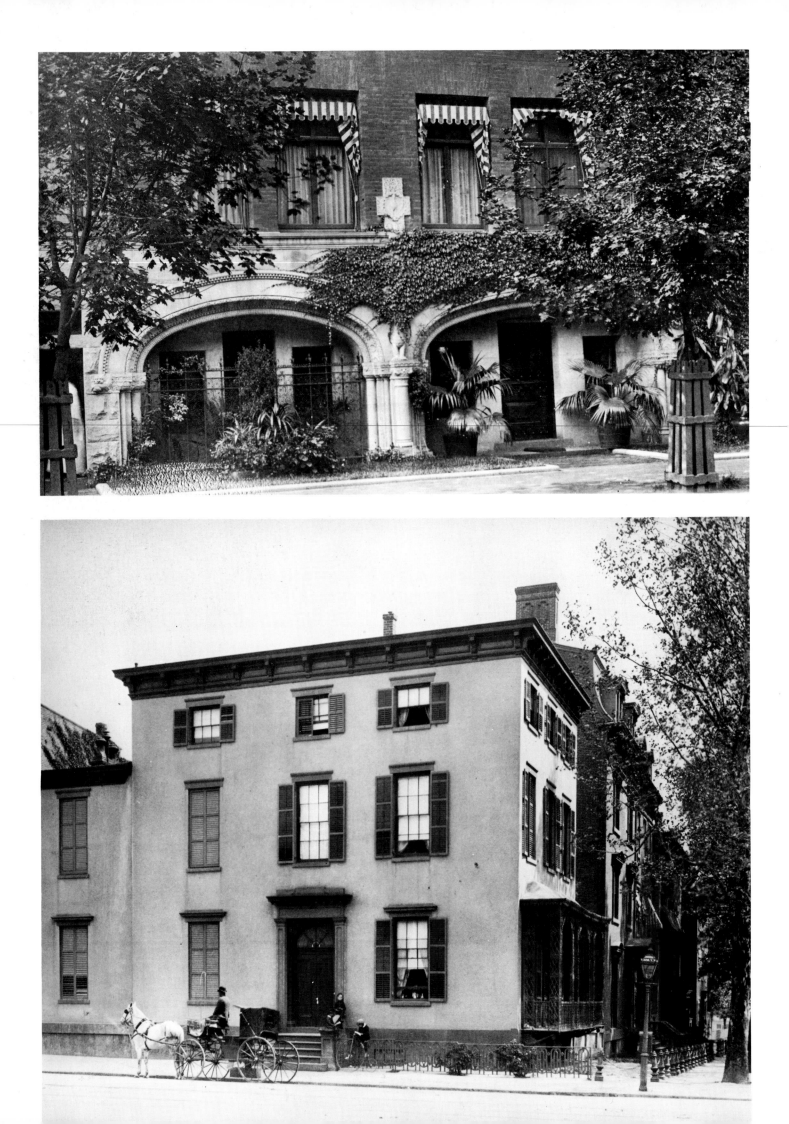

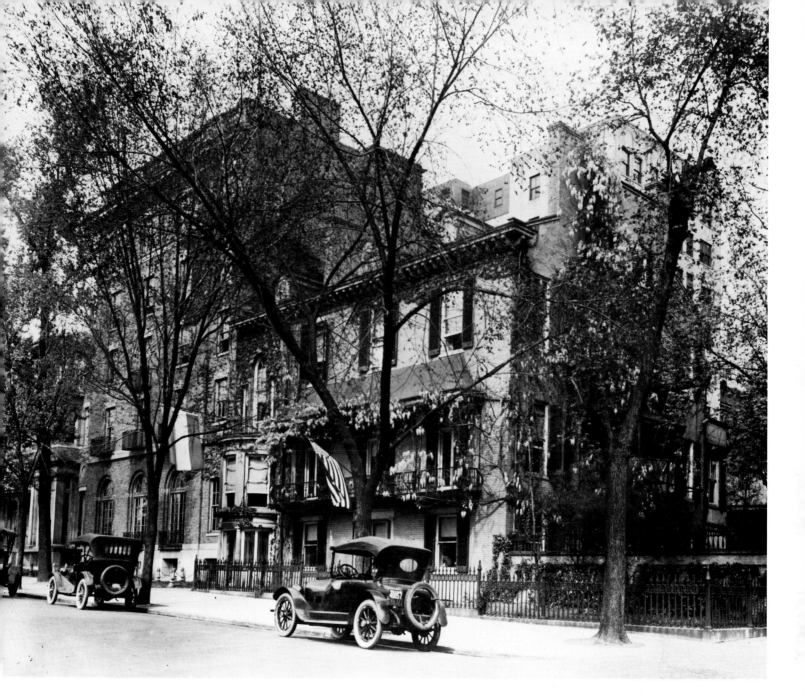

Opposite, top: **180. The Henry Adams House, 1603 H Street, NW, ca. 1898.** Designed in 1885 by Henry Hobson Richardson in the Romanesque Revival style, the house was demolished in 1927. Parts of the stone arches of the double doorway were incorporated in a new house in the Normanstone neighborhood, at 2618 30th Street, NW. A novelist and historian, Adams was considered Washington's foremost private citizen between 1877 and his death in 1918.

Opposite, bottom: **181. The Dolly Madison House, ca. 1888.** In about 1819 Richard Cutts, brother-in-law of Dolly Madison, built this house on the southeast corner of H Street and Madison Place, NW, facing Lafayette Square. After President Madison's death in 1836, his widow Dolly lived there until she died in 1849. During the Civil War, General George McClellan used the house as his headquarters. It

was later purchased by the Cosmos Club and in 1967 it was restored as part of the Lafayette Square redevelopment. Of the square itself, Henry Adams wrote in *The Education of Henry Adams* that in 1868 it "was society . . one found all one's acquaintances as well as hotels, banks, markets and national government. Beyond the Square the country began."

Above: **182. No. 21 Madison Place, NW, ca. 1917.** The structure was built on the "President's Square" (as Lafayette Square is sometimes called) in 1828 by Ogle Tayloe, son of Colonel John Tayloe of Octagon House. Later occupants were Admiral Paulding, Vice-President Hobart and Senator Mark Hanna, who was so close to President McKinley that the building was called The Little White House.

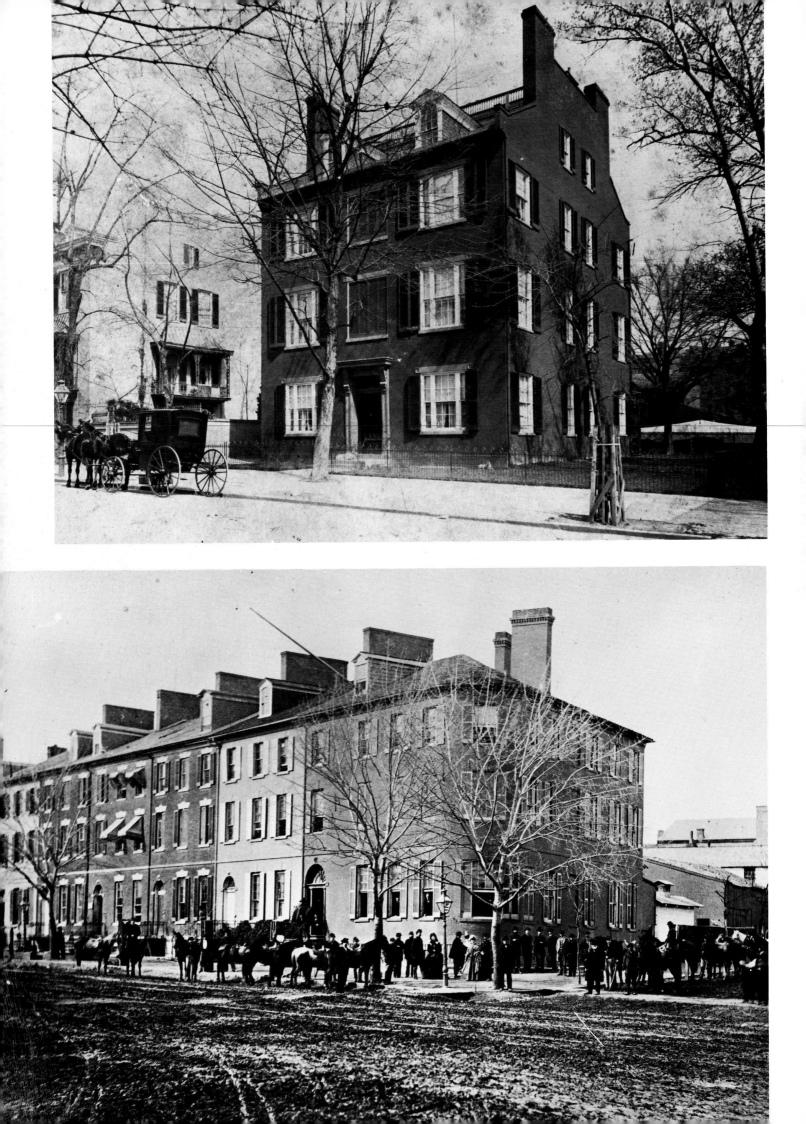

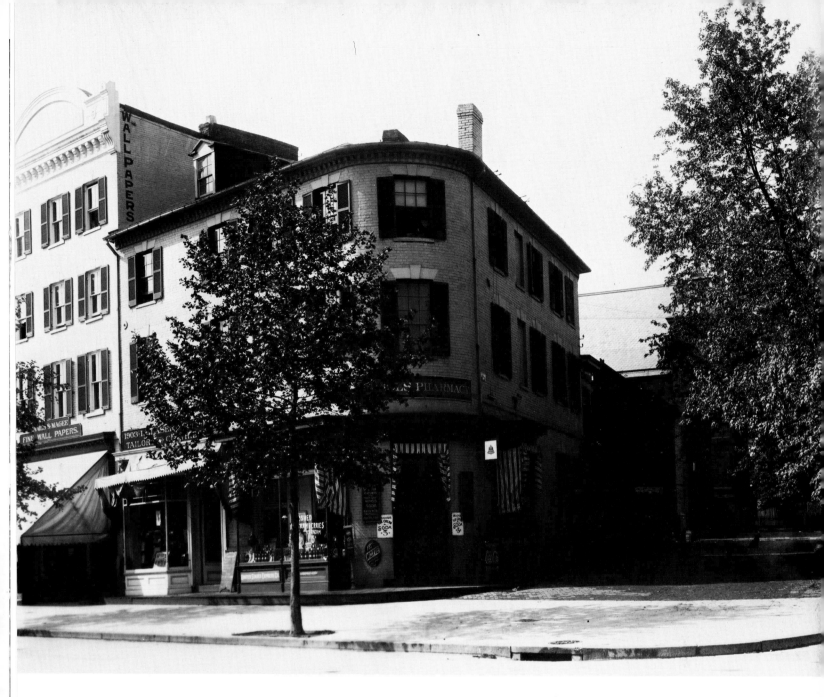

Opposite, top: **183. The John Rogers House, Madison Place, NW, ca. 1880.** Built in about 1833, the house was sold by Mr. Rogers in 1863 to Secretary of State Seward. It was here on April 14, 1865, that Lewis Paine forced his way into Seward's bedroom and stabbed him in the throat as President Lincoln lay dying in the Petersen House, a victim of the same plot. Later the house was occupied by Civil War General Belknap, who became Secretary of War under Grant.

Opposite, bottom: **184. The Seven Buildings, 1901–13 Pennsylvania Avenue, NW, April, 1865.** This row of Federal town houses was erected in the mid-1790s as part of the city's westward expansion away from the expensive lots on Cap-itol Hill. The corner building, only three blocks from the President's House, served as the Department of State when John Marshall was Secretary. The most famous tenants, however, were President and Mrs. James Madison. After the White House was burned by the British in 1814, they took up residence at 1901 from October, 1815 until March, 1817.

Above: **185. No. 1901 Pennsylvania Avenue, NW, ca. 1918.** Once the Madison White House and known as The House of a Thousand Candles, the corner building of the Seven Buildings was later occupied by Nichols Pharmacy and a tailor shop. It was demolished, along with the adjacent structures, in 1958 to make way for a modern office block.

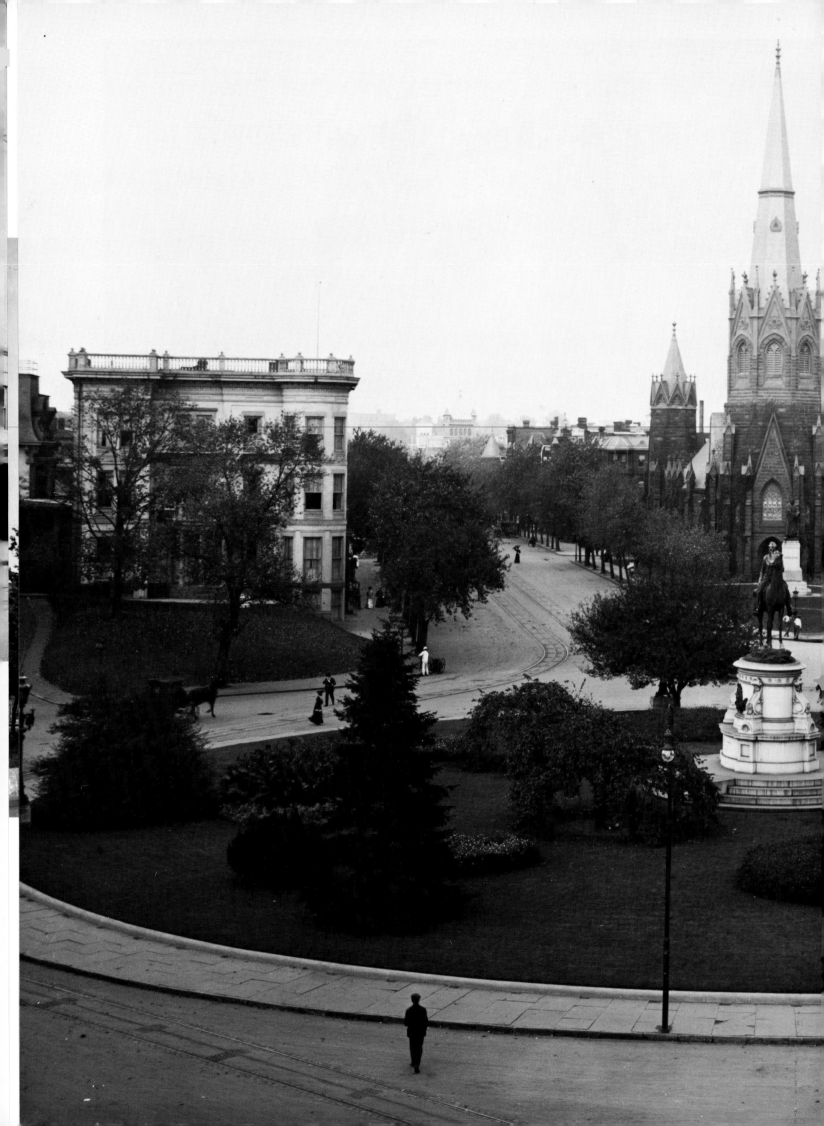

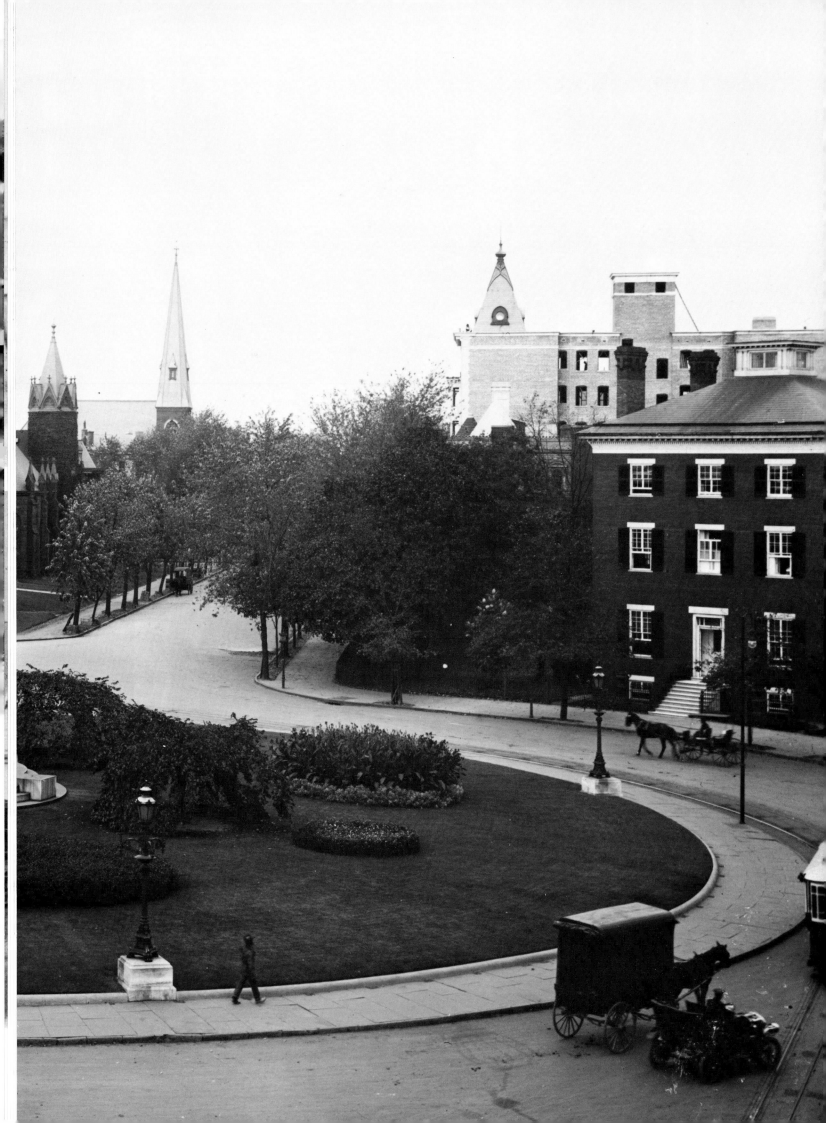

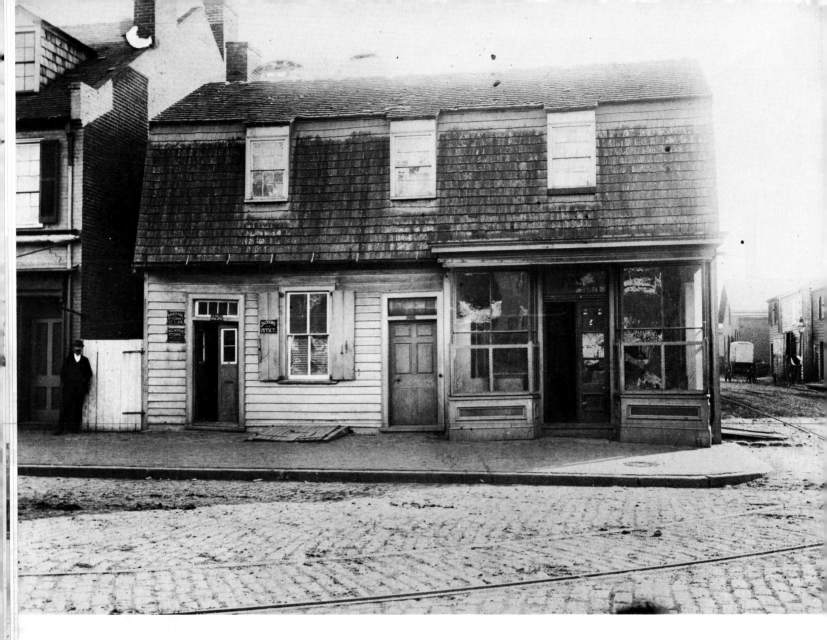

Above: **207. Residence of Merchant Joseph Jackson, 3250 M Street, NW, November 20, 1891.** The gambrel-roofed frame dwelling, rather rare for Georgetown, was built in about 1800 and was torn down in 1892. Its address, originally 59 Bridge Street, was changed in 1895 when Georgetown addresses were brought into conformity with those of Washington.

Opposite: **208. The William Thornton House, 3221 M Street,** NW, 1902. The Victorian storefront of H. G. Wagner's jewelry store disguises the Federal town house once occupied by William Thornton, Architect of the Capitol, designer of Octagon House and Tudor Place and later Superintendent of the Patent Office. It was he who dissuaded the British from burning America's patent records and models in 1814. To the right, at 3219, is Joseph F. Tennant's saloon.

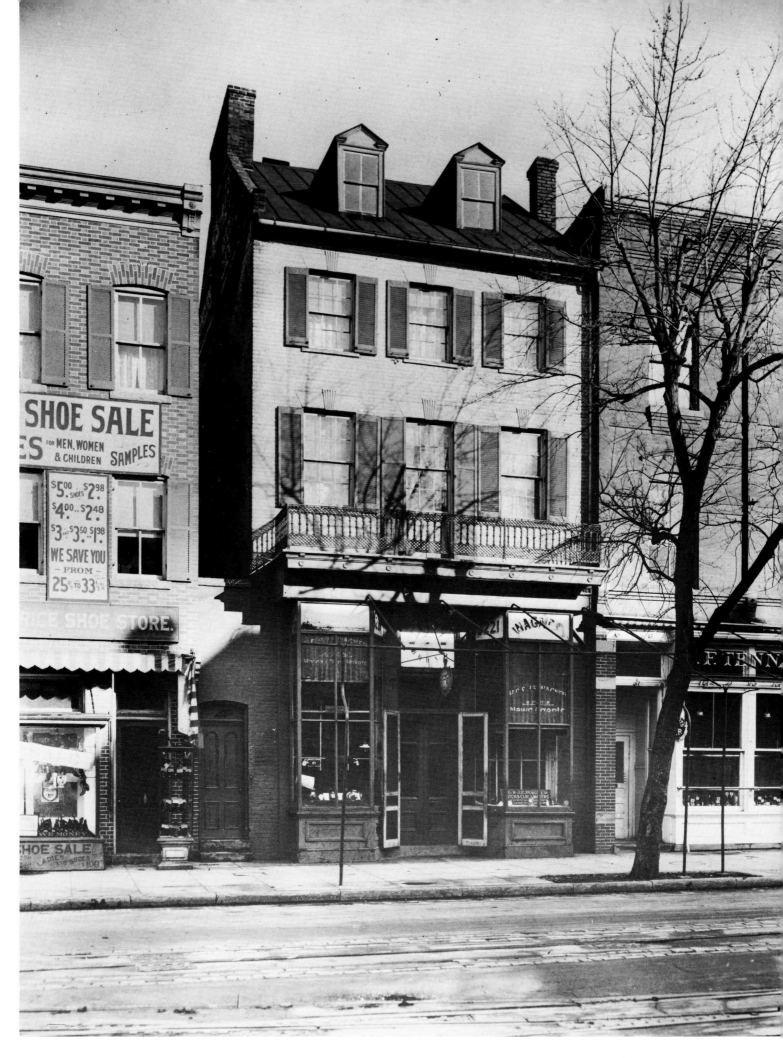

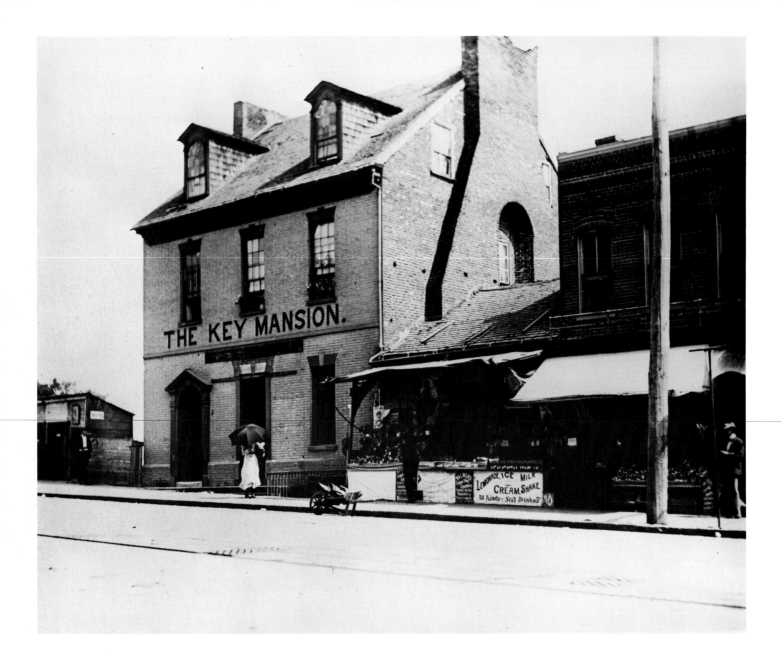

Above: **209. The Francis Scott Key House, 3518 M Street, NW, ca. 1907.** The house was built in 1802 by Thomas Clarke. Key, who was Recorder for the city of Georgetown and later U.S. Attorney for the District of Columbia, lived here from 1805 to 1830. He is, of course, best known for writing *The Star-Spangled Banner.* A porch at the rear of the house overlooked a terraced garden and the Potomac River. The house was destroyed in 1935 to make way for a ramp for the Whitehurst Freeway.

Opposite, top: **210. Aqueduct Bridge, 1889.** Crowds of pedestrians and some cyclists gather to watch the floodwaters of the Potomac, which had been swollen by the same deluge that precipitated the flood that destroyed Johnstown, Pennsylvania.

Opposite, bottom: **211. Georgetown from the West, ca. 1862.** The C & O Canal runs parallel to the Potomac. At the right is the Aqueduct Bridge. The arched pipes directly behind the seated figure are bringing Washington's water supply from upriver.

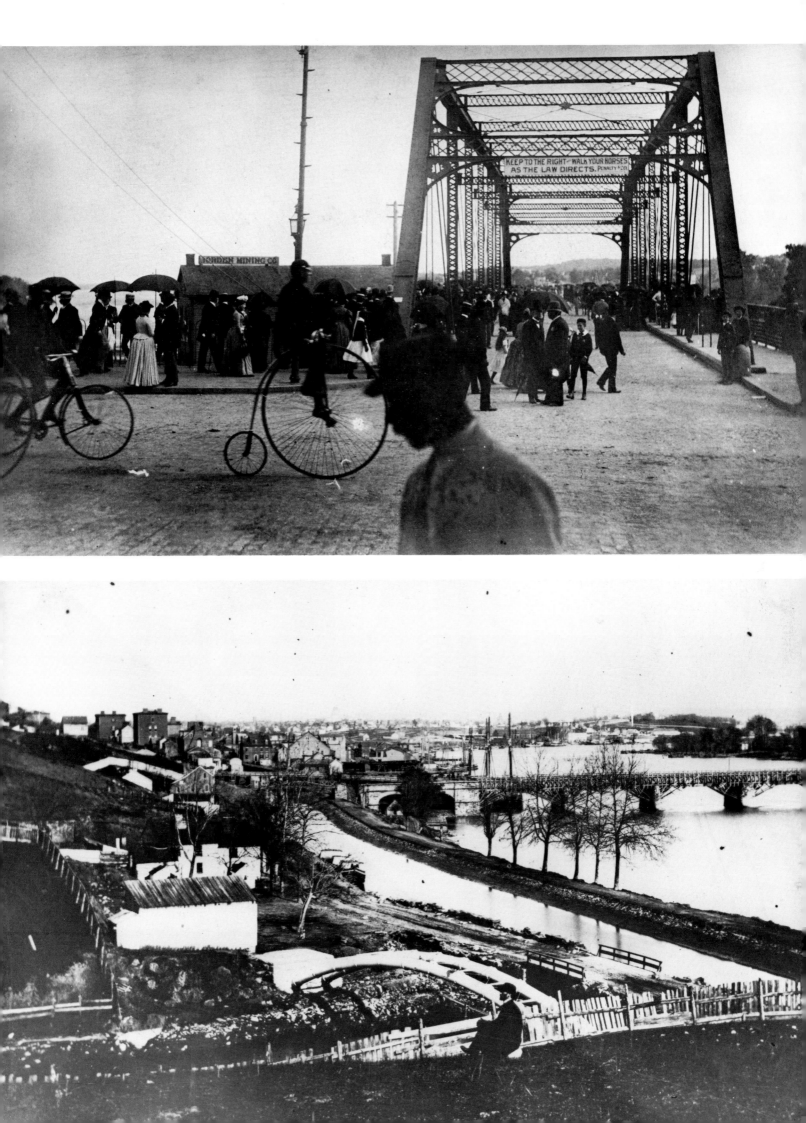

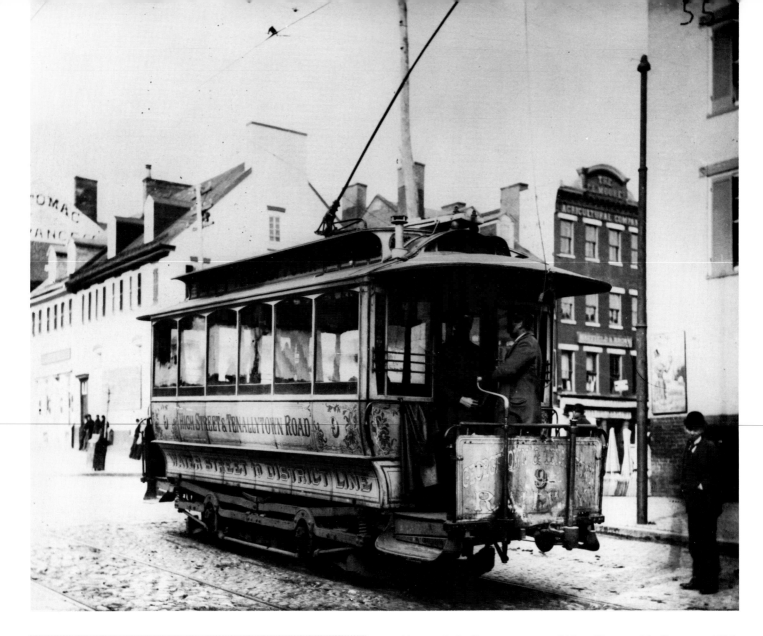

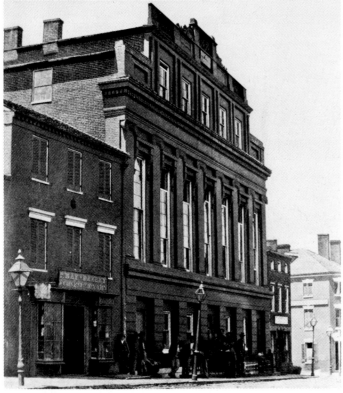

Above: **212. Georgetown and Tenallytown Trolley, ca. 1890.** Car Number 9 stands on Wisconsin Avenue, just below M Street, NW, ready for its run out to Tenallytown, an early settlement in the area of present Wisconsin and Nebraska Avenues.

Left: **213. Forest Hall, 1256 Wisconsin Avenue, NW, ca. 1863.** Built with a colossal Ionic facade in the 1850s as a social gathering place, the hall was used as a Union hospital during the Civil War. Lincoln is said to have visited frequently to comfort his soldiers. In recent times it has gone from being a parking garage to the home of the Design Store. The small store at the right, on the northwest corner of Wisconsin Avenue and N Street, was once the thread and needle shop of W. W. Corcoran, Washington banker, art patron and philanthropist.

Opposite, top: **214. The Steam Launch *Bartholdi*, ca. 1900.** An early spring outing on the Potomac River near Georgetown College. The boat was named for Frédéric Auguste Bartholdi, sculptor of the Statue of Liberty and the fountain in the Botanic Garden near the Capitol.

Opposite, bottom: **215. The Foxall-McKenny House, 3123 Dumbarton Avenue, NW, near Wisconsin Avenue, ca. 1870.** The house was built in about 1805 by Henry Foxall as a wedding gift when his daughter Mary Ann married Samuel McKenny. There is probably no other house in Georgetown that has remained as unaltered through the years as this one.

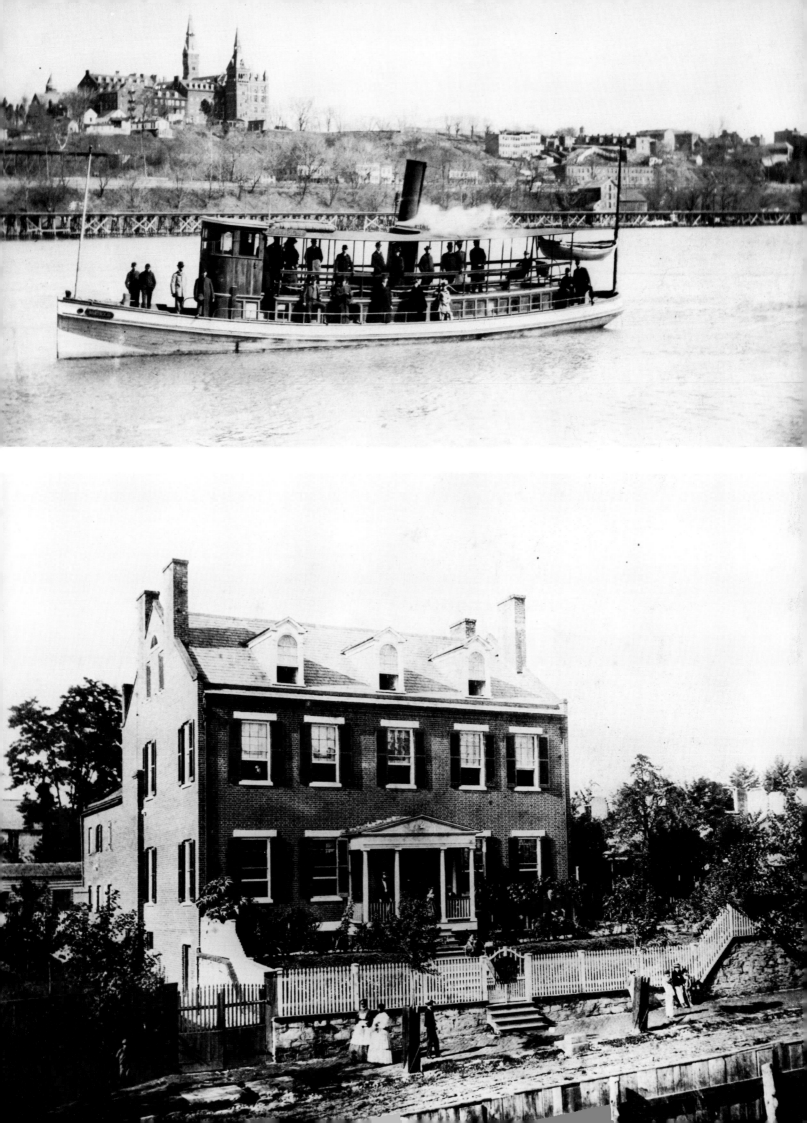

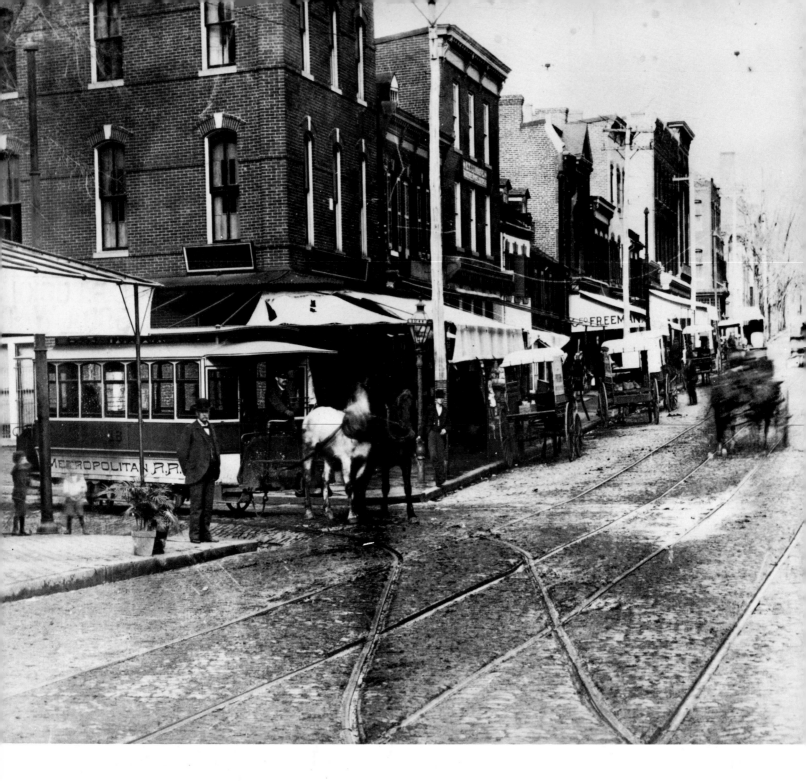

Above: **216. A Metropolitan Horsecar, 1893.** A stop is made near B. F. Baker's grocery at Wisconsin Avenue and O Street, NW, during the trip downtown.

Opposite: **217. The Clement Smith House, 3322 O Street, NW, ca. 1905.** Built in 1815, from 1838 to 1854 this was the home of Alexander, Baron de Bodisco, Russian Ambassador to Washington. During the Civil War the house became headquarters for Union officers. It was later subdivided and now rents as apartments.

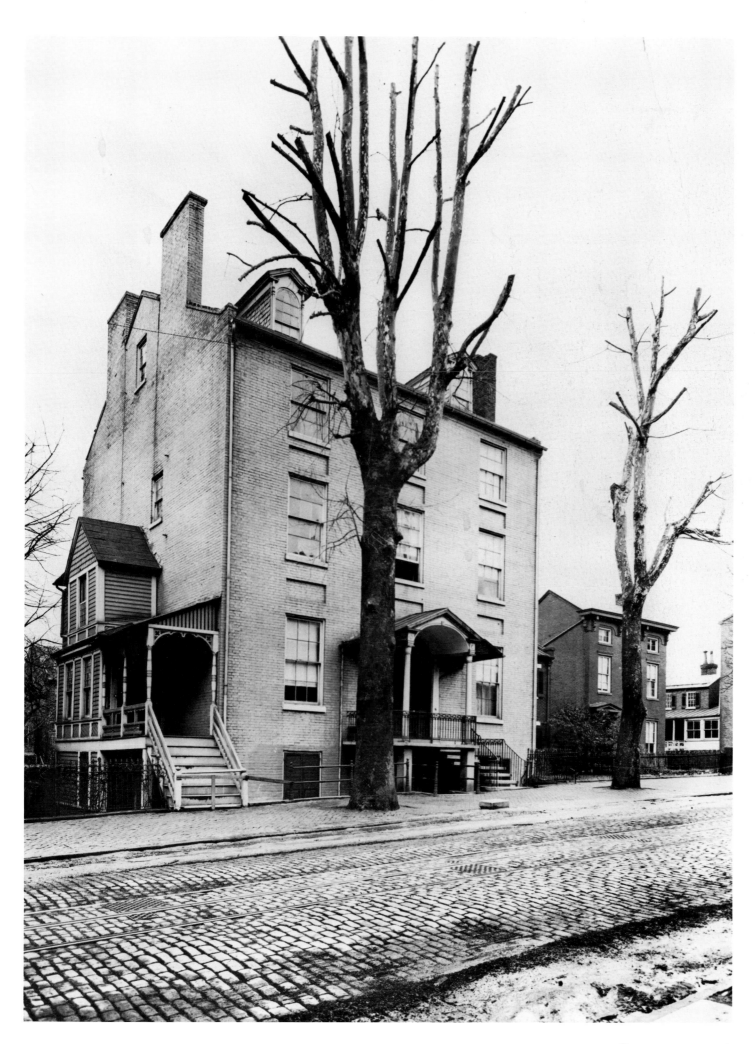

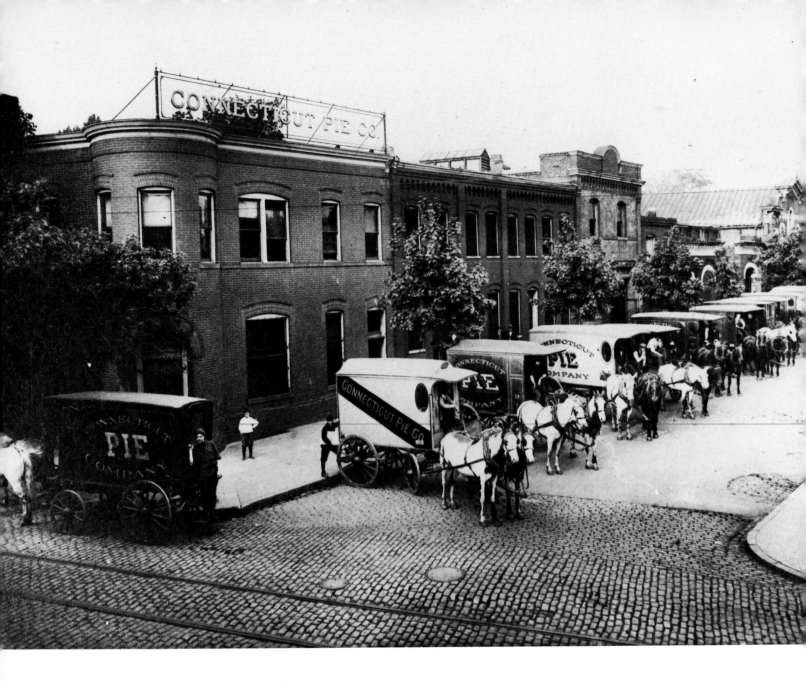

Above: 218. **The Connecticut Pie Company, 3159 O Street, NW, ca. 1900.** The firm was run by the Copperthites, a family of bakers who lived in Georgetown. Their goods were distributed throughout Washington by a fleet of horse-drawn wagons. The building was razed in 1958; a People's Drugstore was later built on the site.

Opposite, top: 219. **P Street Bridge, ca. 1885.** An open horse-car of the Metropolitan Railroad crosses Rock Creek.

Opposite, bottom: 220. **The Francis Dodge House, 30th and Q Streets, NW, ca. 1888.** Andrew Jackson Downing was one of the most famous and popular architects in mid nine-teenth-century America. His books, having national influence, revolutionized landscape gardening. Downing left his mark on Washington: he drew up the master plan for improving the Mall and he also designed two picturesque villas in Georgetown for the Dodge family, who were prominent in the shipping and warehouse businesses. The Francis Dodge house, built in 1852, still stands. Its Italianate style with its irregular shape, asymmetrical tower, arched verandas, and wings was something quite new to old Georgetown, accustomed as it was, and still is, to simpler fare.

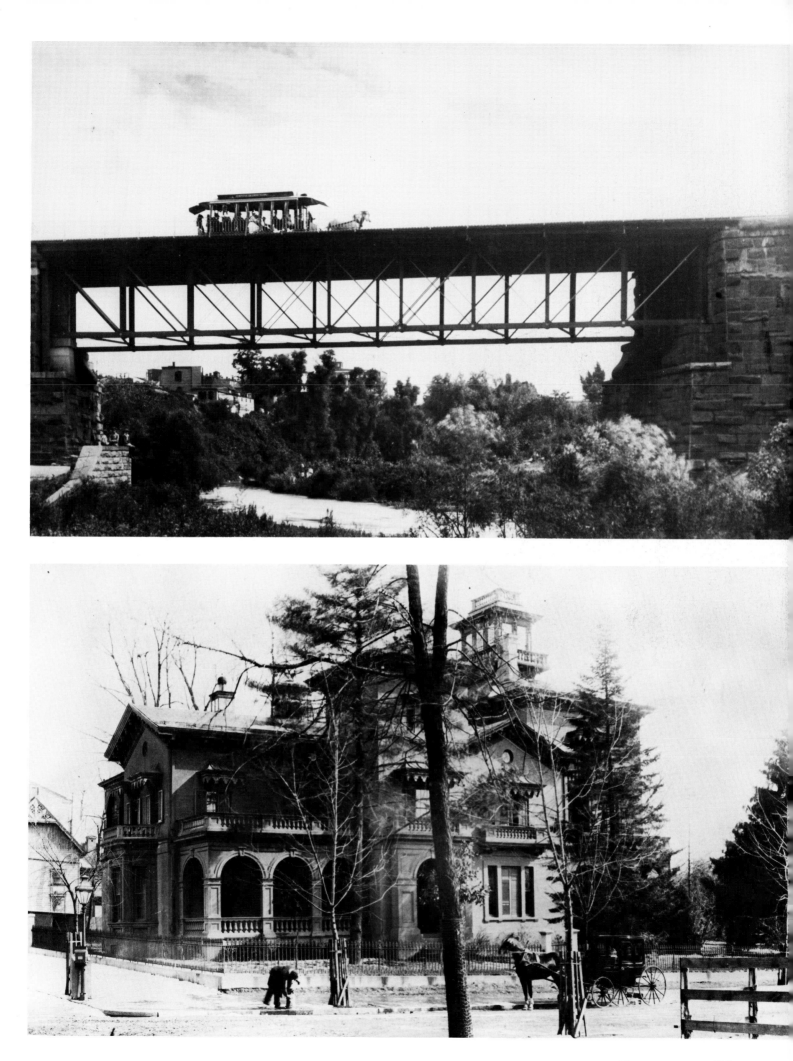

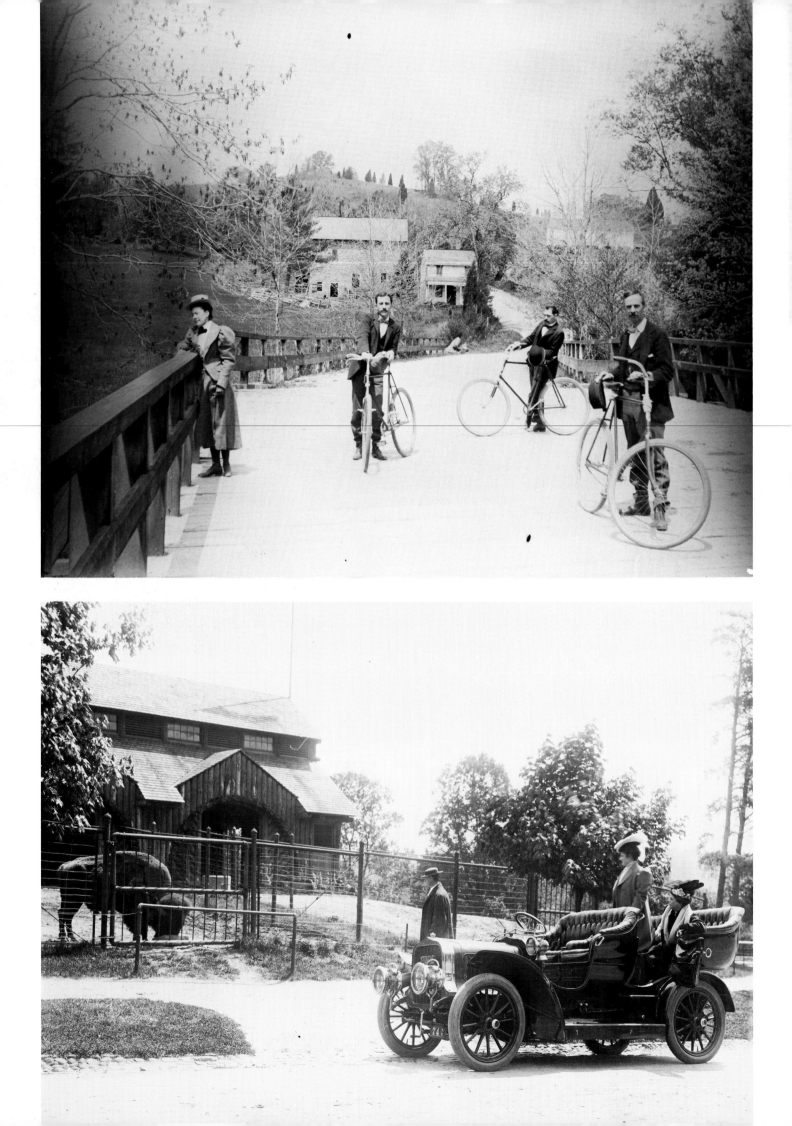

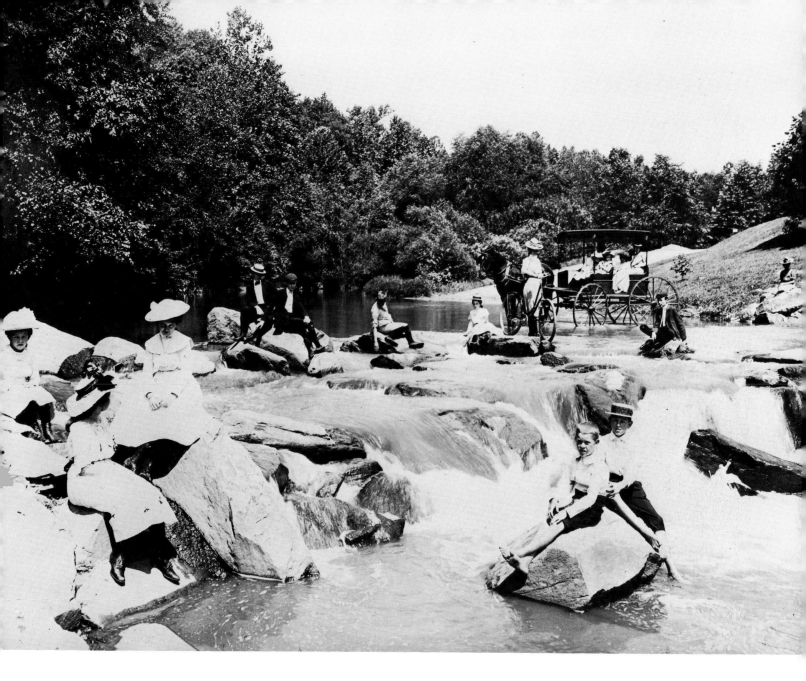

Opposite, top: **221. Cyclists near Pierce Mill, 1893.** In the nineteenth century Rock Creek north of Georgetown wandered through an area that had remained open farmland. The mill and a few outbuildings remain from the Isaac Pierce Plantation, built in 1829. It operated as a grist mill until 1897 and was restored by the WPA in 1936.

Opposite, bottom: **222. The National Zoo's Buffalo House, Rock Creek Park, 1906.** The first national animal collection was housed on the Mall beside the Smithsonian. In 1890 the Smithsonian's regents arranged for funds to move the collection to its present location.

Above: **223. Summer Picnic Party, the Lower Ford of Rock Creek, ca. 1900.** Proposals had been made for establishing a park in the area of Rock Creek Valley since the 1860s, but it was not until 1890 that Congress authorized the money for purchase of the parkland. During his Presidency Theodore Roosevelt enjoyed taking European diplomats, unused to strenuous physical exercise, on hikes through the rugged forests and bluffs of Rock Creek Park.

GENERAL INDEX

This index lists persons (including photographers), businesses, buildings, constructions, monuments, statues, squares, circles and parks mentioned in the captions to the illustrations. The numbers used are those of the illustrations. Streets, neighborhoods, rivers and other sites are not included.

CHRONOLOGICAL INDEX OF PHOTOGRAPHS

The numbers used are those of the illustrations. The indication "ca."
is disregarded for the purposes of this index.